DRAWING
HUMAN
ANATOMY

DRAWING
HUMAN
ANATOMY

GIOVANNI CIVARDI

STUDIO
VISTA

Studio Vista
An imprint of Cassell & Co.
Wellington House, 125 Strand
London WC2R 0BB

This edition first published in Great Britain 1995
by arrangement with
Il Castello Collane Tecniche
via C. Ravizza 16, 20149 Milan
Italy

Reprinted 1995, 1996 {twice}, 1997, 1998 {twice}, 1999 {twice}, 2000, 2001 , 2002

Originally published in Italy 1990 as
Corso di Disegno della Figura Umana
note di anatomia e raffigurazione

British Library Cataloguing in Publication Data
A catalogue record for this book is available from
the British Library

ISBN 0-289-80089-7

English translation by Ardèle Dejey

Distributed in the United States by
Sterling Publishing Co. Inc.
387 Park Avenue South, New York, New York 10016-8810

**Printed and bound in Great Britain
by
The Bath Press, Bath**

CONTENTS

INTRODUCTION

'Anatomy is the art of dissection; of artificially separating the various parts of an organized body to discover their position, shape, structure and function.' This is one possible definition of this purely biological discipline: to investigate, in fact, the living substance of the animal and vegetable kingdoms, which is the oldest, most direct way to identify their structure. It is also the basic cognitive approach to the study of the human organism, particularly for medical and anthropological sciences.

For artistic purposes, a more practical, straightforward way to address the problem of correct depiction is through the study of descriptive and systematic anatomy, which examines the form and structure of parts of the body and classifies them in systems relating to the motion system.

This book is an introduction to the detailed study of the human body *in vivo*, rather than an elementary anatomy text, and it relates purely visual impressions to the 'canons' of proportion. The idea is not new, and there are many books on the subject. However, this is the first time that the association between anatomy and life drawing has been so minutely described.

Basically, artistic anatomy must be seen as a simplified tool for the interpretation of anatomy, and as a guide to intelligent observation, recognizing and therefore expressing (however freely) the characteristics of the human body. Without these basic studies, the student will be at a great disadvantage.

The idea for this book (and for the other two books in the series, *Drawing the Female Nude* and *Drawing the Male Nude*) came to me both from the habitual practice of illustration and sculpture and from my collective and individual teaching experience. The main requirement for those pupils most gifted in drawing was not to base their work on anatomical diagrams (correct, but stereotypes), but to look more attentively at the live model before them. A problem I frequently encountered with beginners was that of finding the right moment to introduce strictly anatomical instruction, while attaining the appropriate balance of observation, knowledge and expression, interpreting them naturally and effectively, without becoming boring and losing freshness of expression and the sheer joy of drawing. In effect, in drawing (as in any other field of knowledge) technical data have to be absorbed to become the instrument for freedom of expression.

The notes on myology (that is, the study of anatomy which deals with the muscular apparatus) are put beside the marginal diagrams of muscles and muscular formations and show their action and morphological importance. They are taken from the notes and graphics that I made over several years while studying for primary medical examinations and while attending practical demonstrations. They show the topographic situation of muscles in the skeleton and have been a great help to me in learning and remembering, and also for use in life classes. It has encouraged me to know that at times some of my own college students have been helped by my summaries.

So I hope that, revised and put together for use in life drawing, these notes will help the student towards the perception of reality and be a stimulus in their efforts to understand and interpret. As with a map of a city, to really experience it, nothing can take the place of seeing with one's own eyes the actuality of streets, houses, monuments and people but, side by side with doing this, having a guide can be helpful for planning the exploration and reducing chance wanderings which, although sometimes interesting, are often incomplete and inconclusive.

NOTES ON THE HUMAN BODY

The complex structure of the human organism is divided into several systems or groups of organs related to the same function.

There are the digestive, the respiratory, the cardiocirculatory, the endocrine and the nervous systems and others, each playing its own part in the functions of the human body. Familiarity with these would be helpful and is therefore recommended if one wishes to make a thorough scholarly investigation but, when applied to life drawing, the most interesting apparatus of the human body is the system of motion (the locomotor apparatus). Here we aim to analyse the apparatus of the skeletal, the muscular and the articular systems, as applied to the functions of supporting and protecting the internal organs and of movement. Hence, the system of motion will be the only one to be discussed here.

It must be remembered, however, that outer bodily forms are determined by bony and muscular conformations and behaviour (as well as by the integumental apparatus – important for individual morphological characteristics *in vivo*), and are obviously influenced by all the other systems, with extensive reciprocal connections.

The human body is subdivided into various parts (called, in life drawing, masses): the head, the neck, the trunk (divided again into the thorax or chest and abdomen or belly), the limbs (divided equally and symmetrically into the upper and lower limbs). For convenience and simplification of study, each of these bodily parts has been subdivided into superficial parts.

Those relating to the motion system were the first to be closely studied by the great artists of the fifteenth and sixteenth centuries, in collaboration with learned men of science, so laying the basis of modern anatomy. From the appearance of the works of Vesalio (1543) the following order of description (especially relating to the skeletal and muscular systems) is used to this day, being demonstrably the only rationally possible way (based on topographical and functional criteria) to learn the relevant terminology and get a clear vision of the human body.

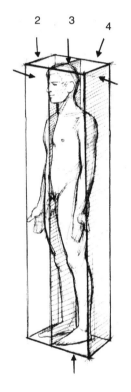

Planes of reference
1 anterior
2 lateral (right)
3 medial
4 posterior
5 lateral (left)
6 inferior

7

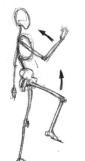

flexion

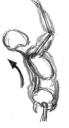

extension

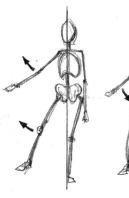

abduction adduction

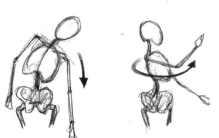

lateral flexion rotation

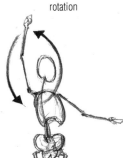

circumlocation

Terms for body positions

For the description of positions of structures the body is assumed to be that of a normal adult, standing upright, with arms (upper limbs) by the side, and the palms of the hands facing forwards, with the heels together and the great toes slightly apart. This is called the 'anatomical position' (it is also that of a corpse lying supine on its back, on a dissecting-room table).

- Imagine the body in a parallelepiped. To describe the position of the six parallelograms bounding the body, we list the imaginary planes:
 anterior (or ventral, frontal, palmar)
 posterior (or dorsal)
 right (right side of the body)
 left (left side of the body)
 superior (or coronal, cranial, rostral)
 inferior (or plantar, caudal).

- Consider the median plane of the parallelepiped. This imaginary, vertical, longitudinal line runs through the middle of the body from front to back (anterior–posterior), dividing it into symmetrical left and right halves:
 medial: nearer the median plane
 lateral: further from the median plane.

- Referring to interior organs (cavitaries), the terms used are: external (superficial) and internal (cavitary); referring to membranes: parietal and visceral.

- In reference to the limbs the preferred terms are:
 proximal and distal: indicating a part of the body or an organ which is nearer to (proximal) or further from (distal) the root of the structure or the centre of the body
 radial (lateral, outer) and ulnar (medial, inner) in the upper limb
 fibular (lateral) and tibial (medial) in the lower limb
 sagittal: certain front-to-back planes parallel to the median plane transversal: certain horizontal planes
 ventral (sometimes used instead of anterior): the part towards which some limbs (forearm, finger, leg) bend
 dorsal: those parts opposite the ventral.

Terms for movement

The following terms are used to describe action, which comes from articulation of parts of the body:
 flexion: this is the turning movement of the sagittal (front-to-back) plane towards the anterior plane
 extension: the opposite movement, directed towards the posterior (nearer the back) plane.

- Referring to the limbs, therefore, flexion describes an action that moves the limb forwards and causes it to bend; extension means the movement that stretches the limb, lengthening it and bending it backwards.
 abduction: drawing away from the median line (sideways from the centre)
 adduction: drawing towards the median line (always on the frontal plane), moving the arm or leg towards the body.

- When describing sideways movements of the trunk, the term lateral flexion is used.
 rotation: the movement of a part of the body around its axis
 circumlocation: a circular movement which occurs on different planes, generally deriving from the summation of some or all of the other movements defined thus far.

NOTES ON
BONE STRUCTURE

The skeletal system is made up of hard, strong elements which support and often protect the internal organs. As passive organs of movement activated by muscles and tendons they cause the torso and limbs to change position in relation to their surroundings. (The importance of mineral deposits should be briefly mentioned, especially their function in maintenance of the haemopoietic level, and of calcium, in relation to bone marrow.)

The adult male skeleton is formed of bone and cartilage (the latter limited to costal cartilage, nasal cartilage, etc.). All the bony parts of the skeleton are, in one way or another, interrelated (with the exception of the hyoid bone) and lead more or less directly to the spinal column which is situated on the median line of the torso. This is the most important supporting structure of the body, carrying the head, forming part of the ribcage (on which the upper limbs converge), and distributing the weight of the torso to the lower limbs, via the pelvis.

Based on these data, a schematic distinction may be made between the axial (cranium, spine and ribcage) and the appendicular skeleton (upper and lower limbs); the two sectors find their connecting structures in the shoulder girdle and the pelvis. The basic facts relative to bone and of interest to the artist are briefly summed up as follows:

External appearance Bones used as studio models have generally been soaked to remove all trace of organic matter. This gives the bone a whitish colour typical of calcification, while in life adult bones tend to be ivory and those of the aged become yellowish. (Models are often made of plastic.)

Number This depends on the embryological criterion of identification and classification (supernumerary, sesamoid, etc.) followed by particular scholars. On average, between 203 and 206 bones are reliably identifiable.

Form While presenting wide variations in appearance, bones can be grouped into two main categories: unpaired median bones, found on the plane of symmetry, and paired bones, of which there are two (left and right), symmetrically related. Within these two broad classes (taking into account, besides appearance, structural characteristics such as the relations between hard and spongy structures), three subdivisions may be made:

long bones: an elongated central part (diaphysis) with two thicker condyles (heads, or epiphyses). Long bones are those with free extremities – humerus, ulna, radius, phalanges, femur, tibia, fibula, etc. Blood-forming marrow is contained in the cavities of the long bones.

flat bones: with length and breadth greater than thickness. Flat bones are those of the cranium, the sternum, the scapula, the ribs.

short bones: with length, breadth and thickness much the same. Short bones are the vertebrae, patella, the bones of the carpus, tarsus, etc.

The by now conventional nomenclatures used in anatomical description are those derived from geometric or functional analogies imposed by ancient definitions. The terms epiphysis, apophysis, tuberosity, spine, furrows and foramen recur in reference to the peculiar morphological characteristics of prominences, depressions or cavities; for the shades of meaning between the different terms it is enough to refer to the introductory section of any good treatise on anatomy.

Microscopic structure Although of little practical use to art students, it is worthwhile briefly to summarize the constituent elements of bone tissue. Each bone, regardless of its shape, is made up of hard tissue consisting of cells held in a matrix of protein fibres and inorganic salts (mostly inorganic

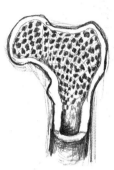

plan of bone
(compact spongy texture)

proximal epiphysis

diaphysis

distal epiphysis

long bones

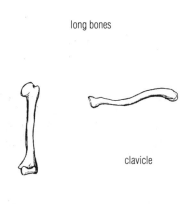

clavicle

humerus

flat bones

occipital scapula

short bones

patella talus

phosphate), with a central mass of spongy substance, dilating into the intertwined trabeculae which contribute both to the bone's lightness and elasticity and to its considerable resistance to external stress. Between the trabeculae lies the bone marrow. The outer surfaces are entirely covered by a fine connective membrane (periosteum), whose function is to supply nutrients to the bone it covers, being rich in osteo-formative (osteoblast) elements for the regeneration of bone tissue. The more minute structures (called second and third orders, i.e. the osseous lacunae, the circular holes of the Haversian canals, etc.) are within the specific field of histology, and are here mentioned only in passing. What should be borne in mind, however, are the changes in bone characteristics and consistency which occur between adulthood and senility, i.e. the process of osteoporosis. There are also considerable physiological and morphological influences induced by habitual body positions, motor and athletic activities which, besides causing muscular changes, may put stress on certain tendinous insertions. The continuous process of osseous restoration may also be affected and the balance between destructive and regenerative processes disturbed.

Following these brief technical notes, we may conclude by defining osteology as the branch of anatomy that studies the morphological characteristics and behaviour of human bones. As stated earlier, the form of the bones is generally described and studied in the appearance they present after they have been soaked to remove all soft matter. There is a danger that because, in life, bones are largely enveloped in muscles or other organs, anyone whose interest in anatomy is purely artistic may undervalue the importance of the bony structure. But knowledge of the characteristics of the principal bones and, especially, their general arrangement, is essential both to the understanding of bodily statics and dynamics and to the ability to depict them in various poses while still convincingly retaining the natural and biologically correct character of the human body.

The characteristics of surfaces and of articular pairing are also important for the artist, because knowledge of them – derived from attentive observation from life of the range of movements the various bodily parts can perform, and from understanding the mechanisms of the joints – assists in the correct placing of muscles and their tendinous insertions, thereby conferring naturalness and expressiveness to the portrayal of dynamic bodily positions.

To give a formative sense to anatomical study (without which it would be arid and pointless), the artist must understand its structural, 'constructive' significance, and be able to determine with precision the bodily position of each bone, recognizing those parts most readily visible under the skin, or easily located by palpation.

NOTES ON MOVEMENT

The articulations that establish the inter-relationships of various bones are either simple contiguous connections (immobile), or ones that govern, in varying degrees, movements between the different bones (mobile and semi-mobile).

Broadly speaking, the joints permit two kinds of movement: axial (sliding and rotating) and angular (flexion, extension, abduction, adduction, circumlocation). Often the complete movement is achieved through the summation, sometimes very complex, of different articular movements,

Knowledge of articular structure and dynamics (at least of the principal mechanisms) is important in the formation of an artist who draws from life. As stated earlier, while the working of joints is seldom apparent externally, an understanding of the limits of their dynamic range is essential to a coherent artistic rendering of bodily movement.

The number of joints which together integrate the bones into a single structure is very large, but they can be broadly grouped into two categories, according to their functional characteristics:

Synarthrosis In character, very restrictive of movement. The joining of two articular surfaces of contiguous bones is achieved by the interposition of connective or cartilaginous tissue capable of differing degrees of deformability which, while permitting minimal changes of position, establishes a structure of continuity between the bony segments. Particular types of synarthrosis are: dentate or squamous sutures, and symphysis.

Diarthrosis This is the typical mobile articulation admitting free movement between two or more adjacent bones. The touching surfaces are covered by cartilages and, between these, there is a very small space (joint cavity) containing synovium, a liquid that reduces friction. The osseous segments are maintained in contact by a fibrous sleeve (articular capsule), reinforced by fibrous bands of varying size (articular ligaments). These mechanisms prevent separation of the articular extremities and limit the maximum extent of movement in the joint.

The category of diarthrosis contains a classification of the various types of joint based on the morphological characteristics of the articulating bone ends, and on the extent of the movement allowed:

arthrosis: this occurs in short bones in which the flat surfaces are in contact with the cartilaginous covering and retained within a sleeve inserted into the edge of the cartilage. It allows only axial movement (sliding, rotating): articulation of the carpus and tarsus;

condyloarthrosis: the smooth, articulating, ovoidal ends of a bone, one concave, the other convex (condyle). Movement is allowed on two angular planes, but not rotation;

enarthrosis: a ball-and-socket joint. This type of articulation allows all angular and rotating movements; their range is restricted only by the joint capsule and ligaments: articulation of the shoulder, hip;

ginglymus: hinge joints; movement is limited to one plane; the bony articulating condyles in contact have superficial cylindroids, one of which is convex, the other concave. Movement may be either rotating (sideways ginglymus) or flexion and extension (angular ginglymus).

Finally, there are the articulating groups, in which various bony heads are involved in a single action and are united by the same capsule: examples are the articulation of the elbow and of the knee.

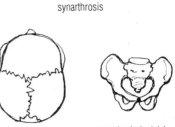

synarthrosis

symphysis (pelvis)

sutural (cranium)

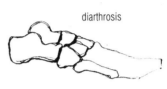

diarthrosis

arthrosis (tarsus)

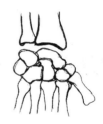

condyloarthrosis
(wrist)

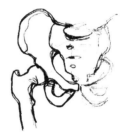

enarthrosis (hip)

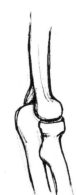

ginglymus (elbow)

NOTES ON MUSCLE STRUCTURE

The muscles relating to the locomotor or motion system belong to the category of voluntary muscles, that is, subordinate to the dominion of the will and, therefore, of the central nervous system. (The other group, the involuntary muscles, consist of those mainly visceral muscles whose movements of contraction or relaxation do not depend on any voluntary action and are included in the study of the autonomous system.) Therefore, the muscles which we discuss here are the active organs of movement of the human body, subject to the will. They are inserted into the bony segments through the tendons and, when contracting (therefore, shortening), determine the displacement within the limits allowed by the relative movement.

The branch of normal human anatomical study that covers the muscular apparatus and its auxiliary formation (myology) is important for the artist who wants to understand and, therefore, be capable of representing exactly (even with complete freedom of expression) the human body in its infinite static and dynamic poses. The muscles form, below the teguments – fatty layers, skin and related structures – the fleshy part of the body which is directly visible to the eye. Mere superficial observation of the nude is not enough for the education of a serious artist as the interpretation of every movement requires both a knowledge of the surface features and function of the affected muscular organs and the examination of their modifications and antagonistic or synergistic inter-relations. The following paragraphs give a brief summary of some of the structural characteristics of muscles, showing how they function.

Muscle structure and form

The contractile part is fleshy and reddish in colour. This is very prominent when in contraction, but even when the muscle is relaxed there is a pre-contractile state (muscle tone), which confers a certain tension to the muscle mass. The surface of the muscle bulge is smooth but, beneath the connective fascia which overlies it, is a light longitudinal muscle bundle. The microscopic structure of the contractile part is, in fact, composed of rough bundles of smaller muscles, which in their turn are formed by muscular cells. Moreover, the presence of other transverse striations in the filaments (made up of groups of muscle cells) brings the skeletal muscles into the category of striated muscles, being the smooth structure typical of the involuntary muscles.

There are tendinous (aponeurotic) parts at each end of the bulge. The tendons characteristically have whitish fibrous tissue (aponeurosis). There is a gradual transition of the inner connective septa from the contractile parts in the tendinous sheaths. Because the tendon is almost inextensible, the traction exerted by the contractile muscle mass is easily transmitted to the point of insertion. Usually, the tendons are like cords but, when they come from flat muscles, they look level, even laminated (aponeurosis). Close to these principal structures are other, complementary ones: connective fascia, tendinous sheaths, mucous bursa. The points of entry of the muscles into the bone (by means of the tendons) are distinguishable conventionally as the point of origin (fixed point, fixed part of skeleton) and the point of insertion (moving point, more mobile part of skeleton). For the skeletal muscles this is determined according to the action of the muscle but, in some cases, the points can be swapped (a few cutaneous muscles have their insertion in the deep layers of the skin).

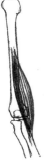

tendon of origin

belly

tendon of insertion

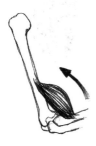

flexion

The form of muscles varies greatly in relation to their separate functions:

long muscles: these are extended, cylindrical, narrowing at the ends. There are different types: biceps, triceps, quadriceps (muscles formed from different muscular bundles united in one tendon of insertion), digastric (double-bellied muscle, joined by a ribbon-like tendon). Long muscles are found mainly in the limbs.

broad muscles: these are usually flattened, sometimes covered by a white fibrous sheet of tissue, mostly located in the trunk. The points of insertion are very broad and establish aponeurosis of insertion.

orbicular or sphincter muscles: these are circular in structure and not found in the skeletal muscular system.

Finally, it must not be forgotten that the muscular system is arranged in layers. These include a more or less superficial covering layer (superficial musculature) and beneath this other, deeper layers (deep musculature). Obviously, the relations between the two systems (superficial and deep) are extremely close and it is important in life drawing to observe the effect each has on the other.

Muscle action

The means of movement of parts of the body are linked to the mode of mechanical function relating to the levers of the limbs of the three basic types. There are various modifications because of the different muscle arrangements and relative lines of force. A single muscle or a group of muscles rarely carries out actions on their own; more often what takes place are complex actions and particular positions, indicated by the following terms:

agonist muscles: those that are opposed in action by another muscle, given different points of origin and insertion.

antagonist muscles: these partially or totally produce opposing actions (typical examples are the extensor and the flexor muscles).

synergistic muscles: the co-operation of two or more muscles which increases the action of another, from the most limited to the most complicated, is called synergism. Synergism occurs frequently and requires a delicate balance between antagonistic strength and opposing synergistic groups.

long muscles

ribbon-like biceps

triceps digastric

broad muscle

orbicular muscle

PRACTICAL HINTS ON LIFE DRAWING

- By 'anatomical drawing' I do not mean the scientific depiction of organs and structures but simply drawing applied to the study of human anatomy, as the body appears *in vivo*, with some understanding of its morphology. For artists, the best path to understanding is by drawing. For this reason I have used sketches rather than photographs to illustrate my point. The main purpose of this book is not to teach how to draw well (that comes later with practice), but to stimulate the ability to observe from life. Even presupposing a certain technical competence in drawing, this must be subordinated to visual education, diligent observation and, above all, to paying heed to the 'canons' of proportion, the sense of volume, the bones and muscles and the dynamics of the bodily areas we study.

- I prefer to use a hard pencil, H, which makes fine lines but is difficult to erase. For the student, a soft pencil such as a 2B would produce better results and be easier to handle. I use cartridge paper (40 × 60 cm), which allows for immediacy, simplicity and speed of execution, together with the possibility of elaboration when required. It even permits a certain degree of abstraction. Once you have learned how to use a pencil and how to teach the eye and hand to draw, other techniques will present few obstacles, and none of them insuperable.

- To make it easier to pick out details of anatomical structure I have chosen to use a male model for these illustrations. Nevertheless, it would have been interesting to have been able to recognize and depict the same structures in men and women of different ages and bodily types.

- Opportunities to practise life drawing are unlimited and not restricted to life classes: human beings are everywhere – swimming pools, gymnasiums, beaches, buses, trains – with opportunities to study them unawares, observing details of faces, hands, legs, with their individual variations. It all makes up the mnemonic and visual language which will later be useful for advanced studies.

- Get used to drawing yourself before hiring a professional model. Note the positions that follow from the action of certain muscles. This is the only way to catch the essence of movement and to understand the essentials of expressing it through the medium of drawing, omitting the superfluous and accidental. Try it in a direct pose (by looking at your hand, for example) or one reflected in one or more mirrors. It is laborious, but an excellent way to learn.

- Modern methods of visual research (fast photographs, television takes and slow-motion cameras, video-recording, computer graphics and others, even more complicated) allow for a total and accurate analysis of human and animal movement. These are specialist investigations but they can be useful to the artist for documenting material.

The student must not feel restricted by exact scientific expression. A generally accepted way of study (barring, that is, movements too fast and complex to be perceived and analysed by the eye) is to observe skeletal and muscular dynamics from life. However, when drawing from photographs remember to watch for changes in perspective and volume: sometimes they are imperceptible but, in spite of the technical perfection of the apparatus, they are always there. Lighting, too, can alter the values of the uneven surface of the muscle mass. Blow up a photograph or negative, project it on to a large sheet of paper and trace the outlines of the figure; this will give an idea of what I mean.

- Finding a skeleton could be difficult. Anatomical material is becoming scarce even for medical schools, but art students have a wider scope and substitutes are available everywhere. If there is no skeleton at your school, or it is incomplete, it may be possible to acquire one in synthetic material, which is just as useful and, being articulated, can be arranged in any desired position. Or, visits to the local natural history museum can be organized. For the muscular structure and other details, a scientific atlas or library anatomy book can be consulted. They are purposely made to meet the needs of students who have increasingly rare opportunities to study in *sala anatomica*. Remember, however, that the anatomical philosophy of the artist differs from that of the medical student or practitioner and should not be overwhelmed or inhibited by solely biological and anthropometric analyses. These would be counter-productive and of limited usefulness.

- Above all, when drawing bones, try to understand their general form and dimensions in relation to the entire skeleton, considering all its aspects, such as those parts just below the skin, close to the large articulations.
 When drawing muscles look at the general conformation, the volume, in states of contraction, in the required pose. What counts for our purposes is the exact position of the muscle mass as it appears *in vivo*, and how the masses are related to the bones. Always think in pictorial and sculptural forms: mass, volume, light, relations. Mentally see the body parts you are going to draw as inter-related 'blocks'.

- Sometimes, drawing the whole or part figure, life size or larger, on enormous sheets of paper or cardboard, using various media (pastel, charcoal, etc.) does not encourage the observation of small details. Instead, study the structural lines. See the body as a series of blocks or wedges and note their relations to each other on the three possible planes of movement. Imagine the interior structure of the body (the large bones) and observe the outside conformation (what is visible) and be alert to sensing the intermediary layers.
 It is always helpful to draw the figure on a small scale very simply, from the basic skeleton. Consider the proportions, the character of the pose, where the articulations occur, the orientation of the limbs. Look at the living model, trace out the obvious anatomical sections and interpret them in your own way.

HEAD MUSCLES

The head is mainly composed of bony elements that can be divided into two parts: the cranial vault (calvaria or skull-cap), formed of flat bones that enclose the brain, and the planes of the face (with the mandible, the only movable bone in the head) which make up the facial skeleton. The muscles attached to the facial skeleton are divided into two groups: the muscles of mastication, between the cranium and mandible (the temporal, the masseter and the buccinator), and the muscles of facial expression, which include those of the mouth (greater and lesser zygomaticus), eyelids, nose and scalp.

The principal muscles of the locomotor apparatus are listed below. The abbreviations o, i, a, stand for origin, insertion, action.

Epicranius

Frontal and occipital joined by a tendinous membrane (galea capitis).

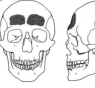

FRONTAL	o: superficial fascia of the forehead
	i: galea aponeurotica
	a: raises eyebrows and skin of forehead (expressions: attentive, surprised, fearful)
OCCIPITAL	o: occipital (superior nuchal line)
	i: galea aponeurotica
	a: draws scale slightly backwards

Procerus

The extension behind the nose of some small muscle fibres of the frontal muscle.

o: root of nose
i: skin of glabella (small area between the eyebrows)
a: draws down the medial angle of eyebrow and produces transverse wrinkles over bridge of the nose (expressions: threatening, sad, aggressive)

Cartilage of the Ear

In humans, the muscles of the ear are hardly more than cartilaginous elastic bands, drawing it into folds.

ANTERIOR SUPERIOR	o: galea aponeurotica and fascia of auriculotemporal muscle
	i: roots of the auricle
POSTERIOR	o: tendons of insertion of sternocleidomastoid muscle
	i: roots of the auricle
	a: slight movement of the auricle or outer ear

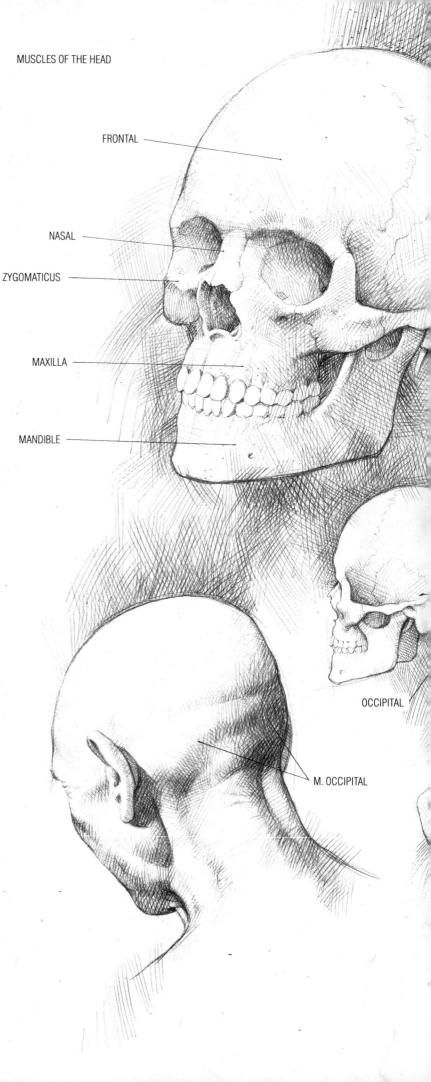

MUSCLES OF THE HEAD

FRONTAL

NASAL

ZYGOMATICUS

MAXILLA

MANDIBLE

OCCIPITAL

M. OCCIPITAL

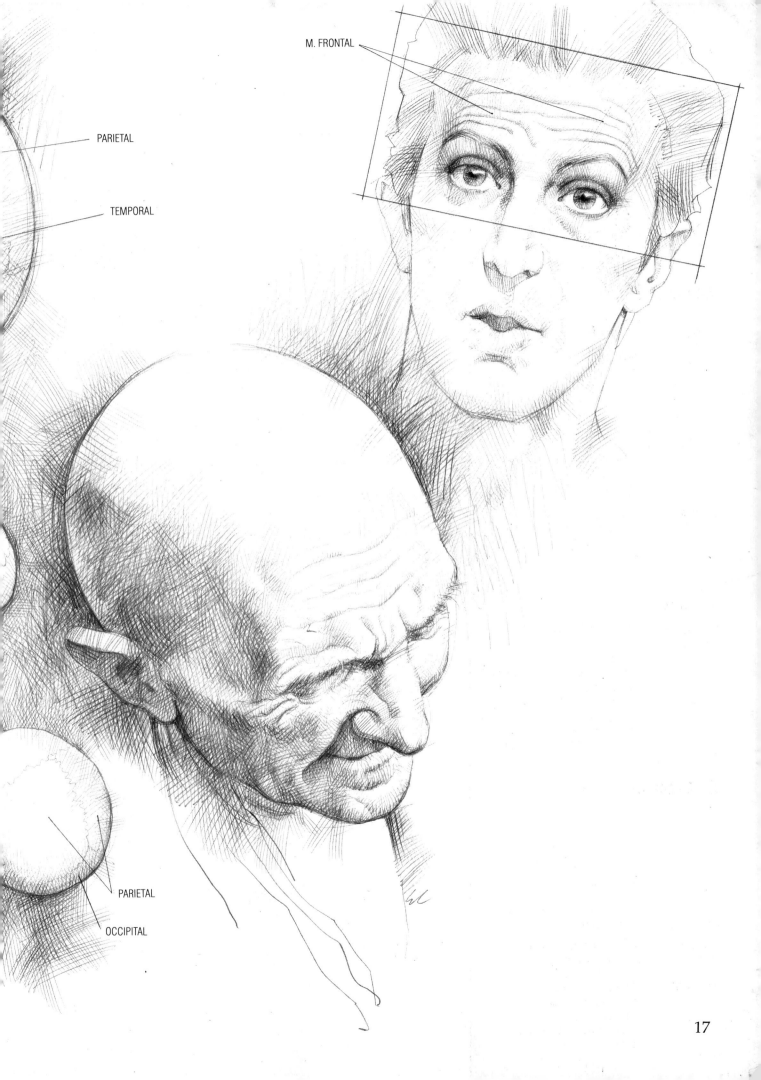

M. FRONTAL

PARIETAL

TEMPORAL

PARIETAL

OCCIPITAL

17

Orbicularis Oculi (Muscles of the Eyelid)

Consists of three parts: orbital, palpebral and lacrimal.

o: frontal process of maxilla, medial palpebral ligament
i: surrounds orbital ring, extends to eyebrow
a: closes eyelids, draws eyebrows towards centre (expressions: laughing, thinking, meditating)

Depressor Muscles of the Eyebrows

o: frontal bone (nasal part)
i: skin surrounding eyebrows
a: draws eyebrows towards centre and downwards

Corrugator Muscles of the Eyebrows

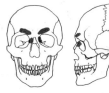

o: nasal part of frontal bone
i: skin surrounding eyebrows
a: wrinkles forehead, draws together and raises eyebrows (expressions: anger, sorrow)

Nasalis

o: alveolar process of the maxilla (near canine muscle)
i: nostrils, wing of nose
a: pinches nostrils, pulls nose down, causing puckering of bridge of nose (expressions: sorrow, disgust)

Nasalis (Dilator Naris)

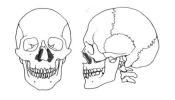

o: alveolar fossa of canine muscle, lateral edge of nostril
i: wings of nostrils
a: lifts and dilates nostrils (expressions: anger, sniffing action, breathing deeply)

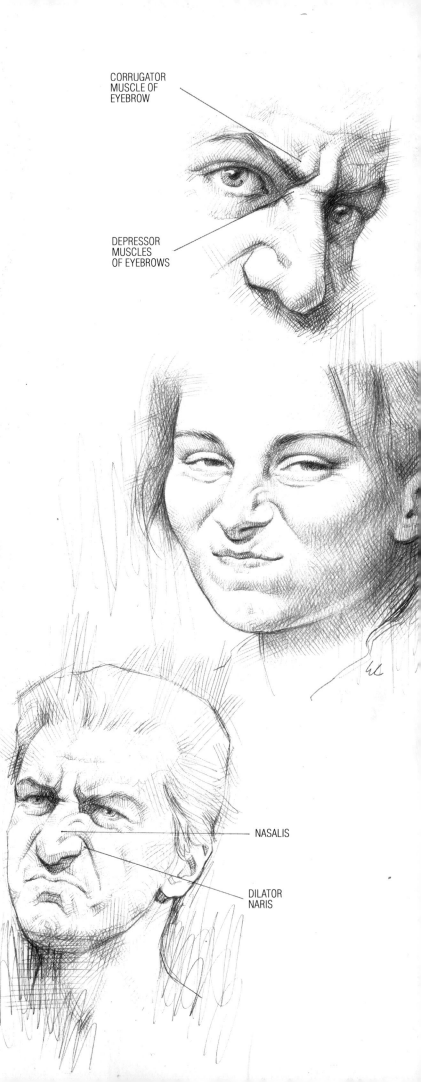

CORRUGATOR MUSCLE OF EYEBROW

DEPRESSOR MUSCLES OF EYEBROWS

NASALIS

DILATOR NARIS

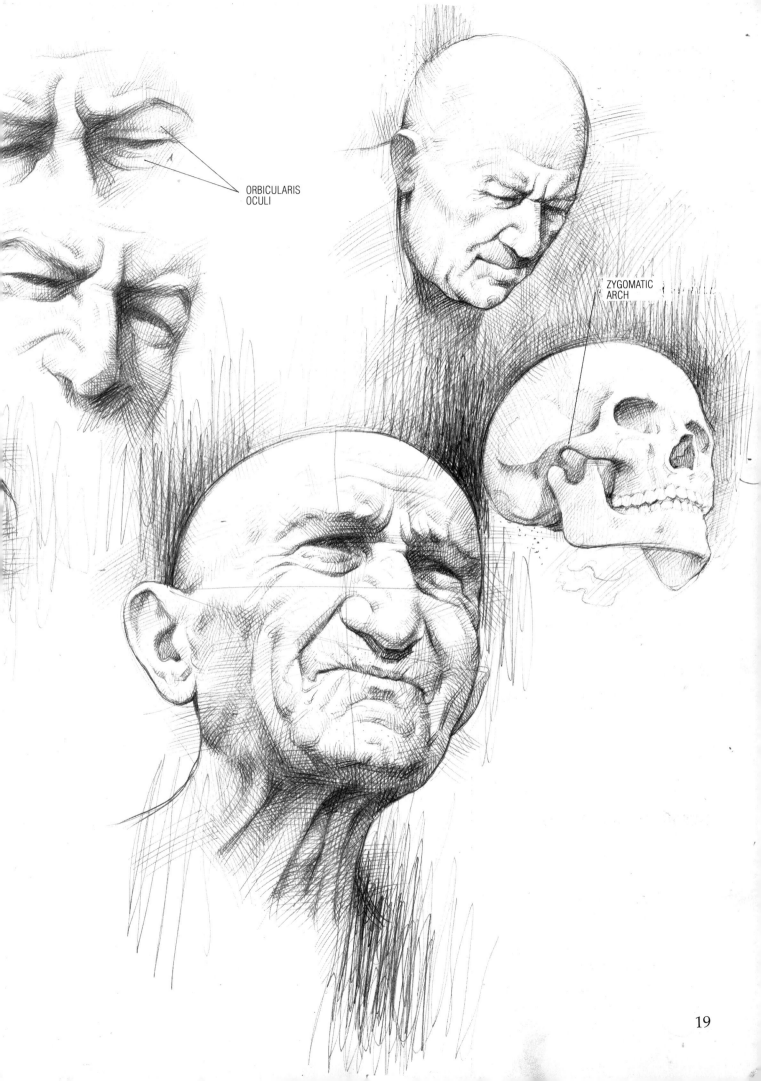

ORBICULARIS
OCULI

ZYGOMATIC
ARCH

19

Quadratus Muscle of the Upper Lip

Three facial muscles meet at the upper lip: the overall action is to pull it upwards and sideways, dilating the nostrils (expressions: contempt, pity, grief, weeping)

Levator Labii Superioris Alaeque Nasi

 o: frontal process of maxilla and orbicular muscle
 i: wings of the nose and upper lip

Levator Labii Superioris

 o: orbital margin of maxilla
 i: wings of nose and upper lip

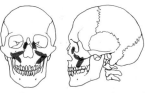

Zygomaticus Minor

 o: zygomatic bone and canine fossa
 i: upper lip and angle of mouth

Zygomaticus Major

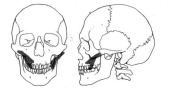

 o: zygomatic bone
 i: angle of mouth
 a: raises upper lip and mouth high and sideways (expressions: smiling, laughing)

Risorius

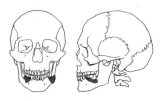

 o: risorius muscle passes from parotid fascia to the skin at angle of mouth
 i: corners of mouth
 a: pulls corners of mouth sideways (expression: forced laugh)

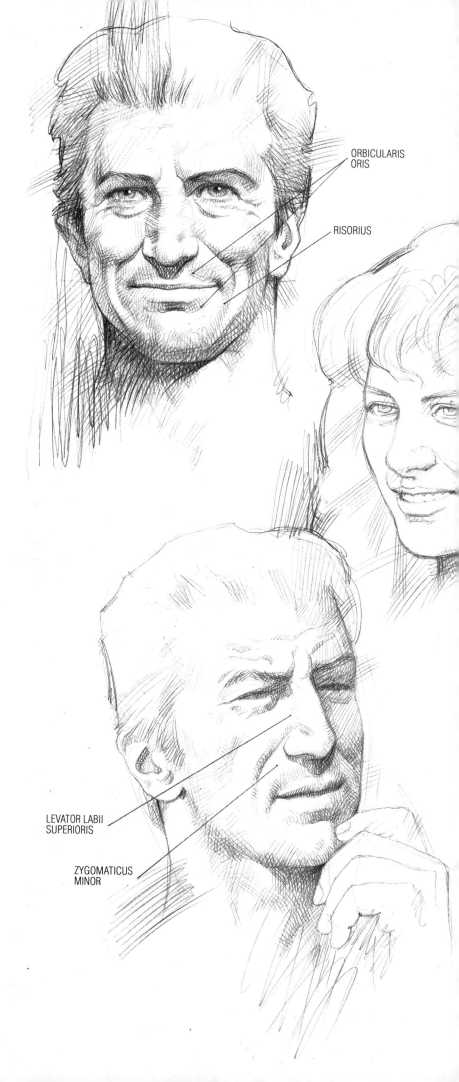

ORBICULARIS ORIS

RISORIUS

LEVATOR LABII SUPERIORIS

ZYGOMATICUS MINOR

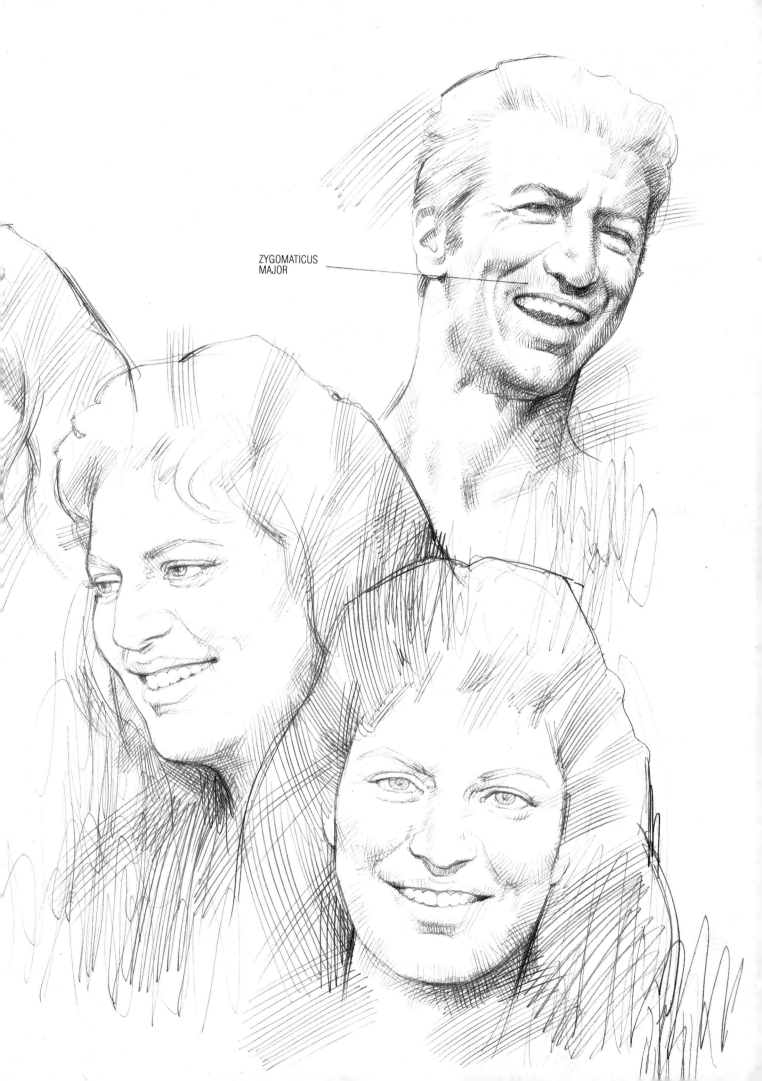

ZYGOMATICUS
MAJOR

Triangularis Muscle

Covers the quadratus muscle of the lower lip (the orbicularis oris, depressor labii inferioris) strengthening its action.

o: base of mandible
i: angle of mouth and lower lip
a: bends downwards angle of mouth and lower lip (expressions: contempt, indignation)

Levator Labii Superioris

o: maxilla (canine fossa)
i: upper lip and angle of mouth

Mentalis

o: mandible (near incisors)
i: skin of chin
a: pulls out lower lip, wrinkles chin

Orbicularis Oris

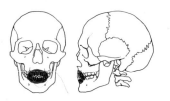

o: muscle fibres of the buccinator (mastication) and other muscles around the mouth are joined to the small fascia of maxilla and mandible, surrounding the edge of mouth
i: skin of lips
a: closes lips and pushes them outwards (expressions: act of kissing, whistling, sucking)

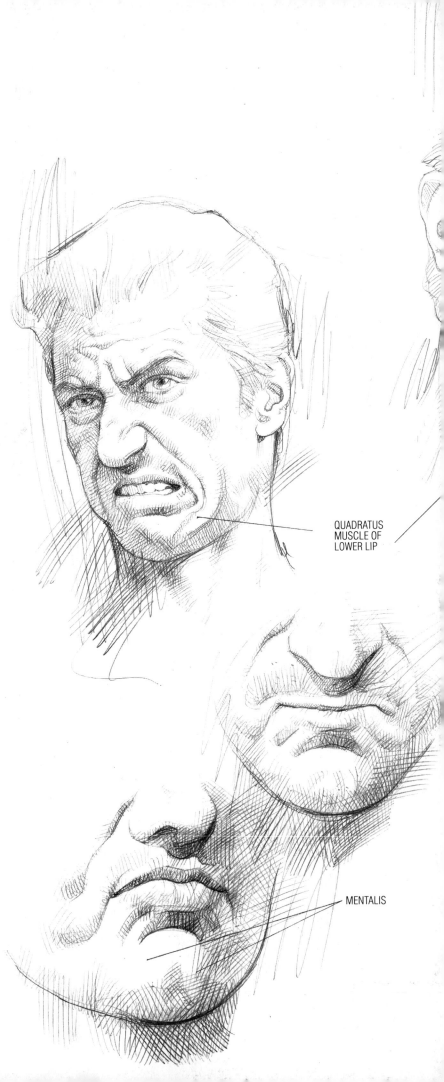

QUADRATUS MUSCLE OF LOWER LIP

MENTALIS

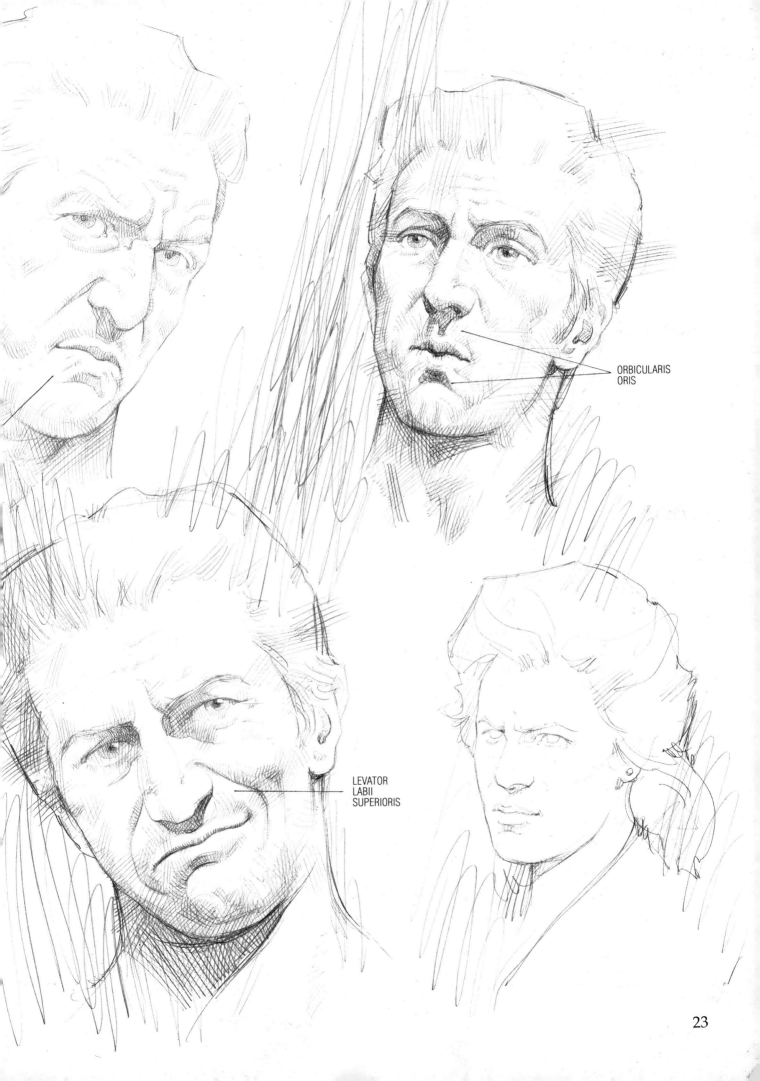

ORBICULARIS
ORIS

LEVATOR
LABII
SUPERIORIS

23

Buccinator

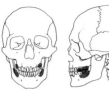

o: jaw (alveolar process), mandible
i: angle of mouth, upper and lower lip
a: pulls back angle of mouth, stretching the circular muscle round the cavity of mouth, and compressing lips and cheek against teeth (expressions: puffing out cheeks, blowing)

Canine Eminence

o: jaw (canine fossa)
i: orbicularis oris
a: lifts angle of mouth and sides of upper lip (expression: gnashing teeth)

Incisor of the Upper Lip
Incisor of the Lower Lip

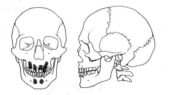

o: maxilla and mandible (alveolar fossa of incisors)
i: orbicularis oris
a: raises upper lip/depresses lower lip

Masseter

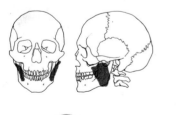

o: zygomatic arch (cheekbone)
i: lateral fascia of the ramus of mandible
a: closes mouth, raising lower jaw against maxilla (mastication), pushing out mandible (expressions: aggressive, emotional tension, anger)

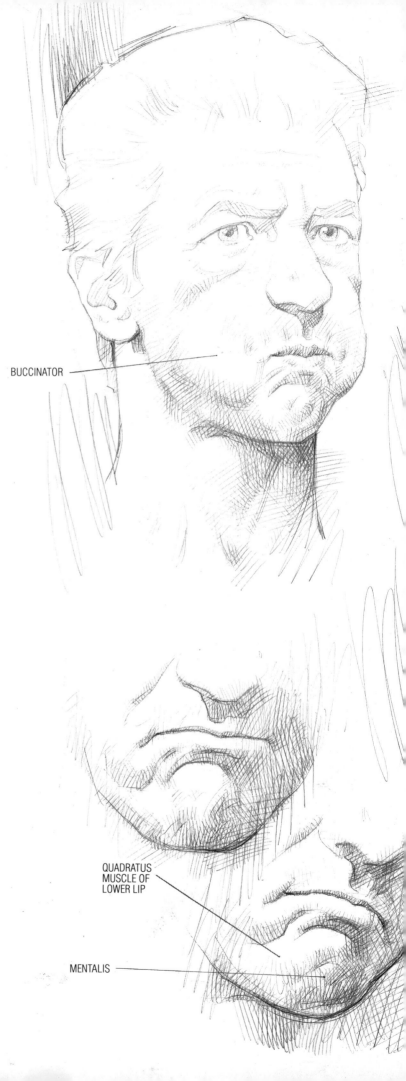

BUCCINATOR

QUADRATUS MUSCLE OF LOWER LIP

MENTALIS

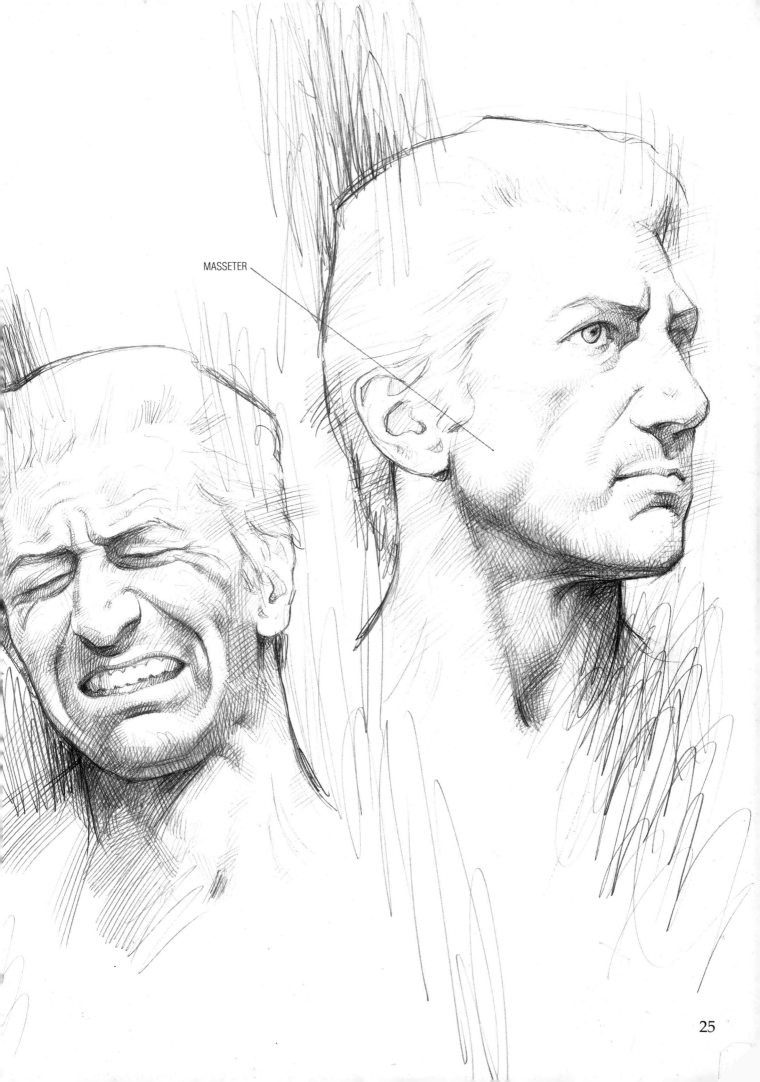

MASSETER

Temporal

o: temporal, parietal, sphenoid
(temporal fossa)
i: coronoid process of mandible
a: closes mouth (mastication), moves
jaw backwards and sideways

Pterygoid

These are the lateral and medial pterygoids, the muscles that
come from the external fascia of the cranial base to the medial
fascia of the mandible, and are therefore insignificant in
external morphology. They work together with other
masticatory muscles to close the mouth and move the jaw.

Platysma

o: a sheathing from chest and shoulder
to masseter and angle of mouth
i: mandible (lower jaw), with branches
to angle of mouth
a: pulls down mandible and corner of
mouth (expressions: this broad, thready
skin muscle, under physical strain,
shows anger, pain, wrinkling skin of neck)

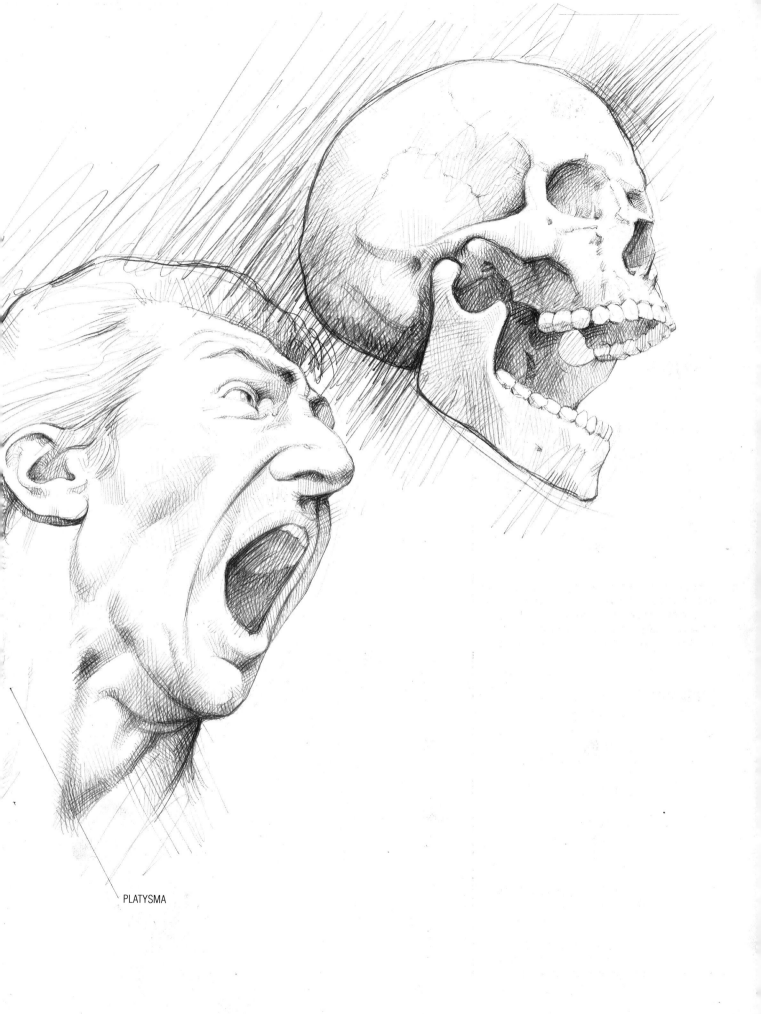

PLATYSMA

27

NECK MUSCLES

The neck connects the head to the trunk. The muscles are grouped around the cervical vertebrae and the first sections of the digestive and respiratory tracts, together giving the neck a roughly cylindrical appearance, spreading out at the base into the chest.

The following groups can be distinguished: the scalenus muscles; the anterolateral muscles divided into suprahyoid and infrahyoid muscles by the presence of the hyoid bone (which covers the larynx where the thyroid cartilage is clearly visible and part of the trachea); and a lateral muscle (sternocleidomastoid). The muscles of the posterior group (trapezius, rhomboid, splenius, etc.) are related to the dorsal part of the trunk. The anterolateral musculature is sheathed by a membranous lamina over which the platysma extends and where the superficial veins of the neck run.

Scalenus Muscles

These are divided into: anterior, medius, posterior

o: transverse process of the 3rd, 4th and 5th cervical vertebrae
i: upper border of first two ribs (anterior and lateral)
a: lifts first two ribs (inhalation), bends cervical vertebral tract sideways

Sternocleidomastoid Muscle

o: sternal head: manubrium of sternum (lower border); clavicular head: clavicle (upper border of sternum)
i: •mastoid process of temporal and occipital bones
a: bends neck forwards and sideways, twists head

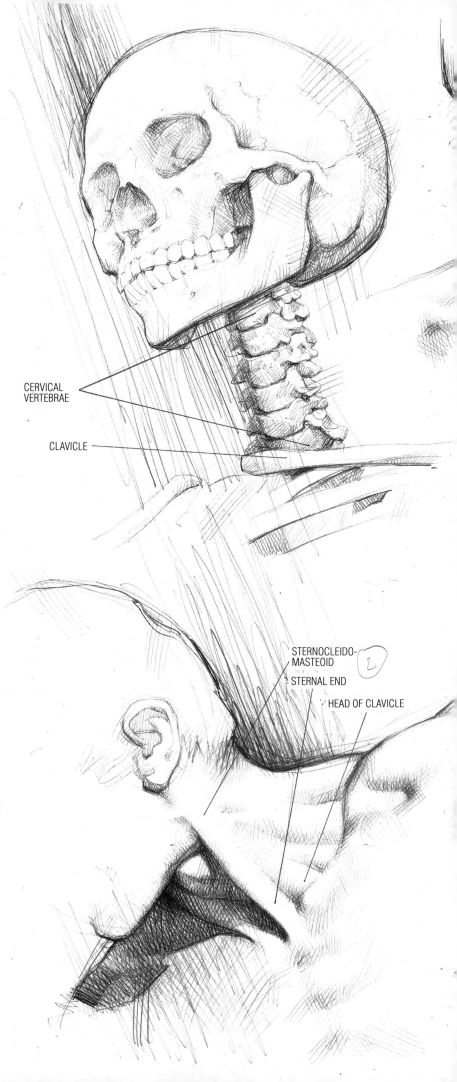

CERVICAL VERTEBRAE

CLAVICLE

STERNOCLEIDO-MASTEOID

STERNAL END

HEAD OF CLAVICLE

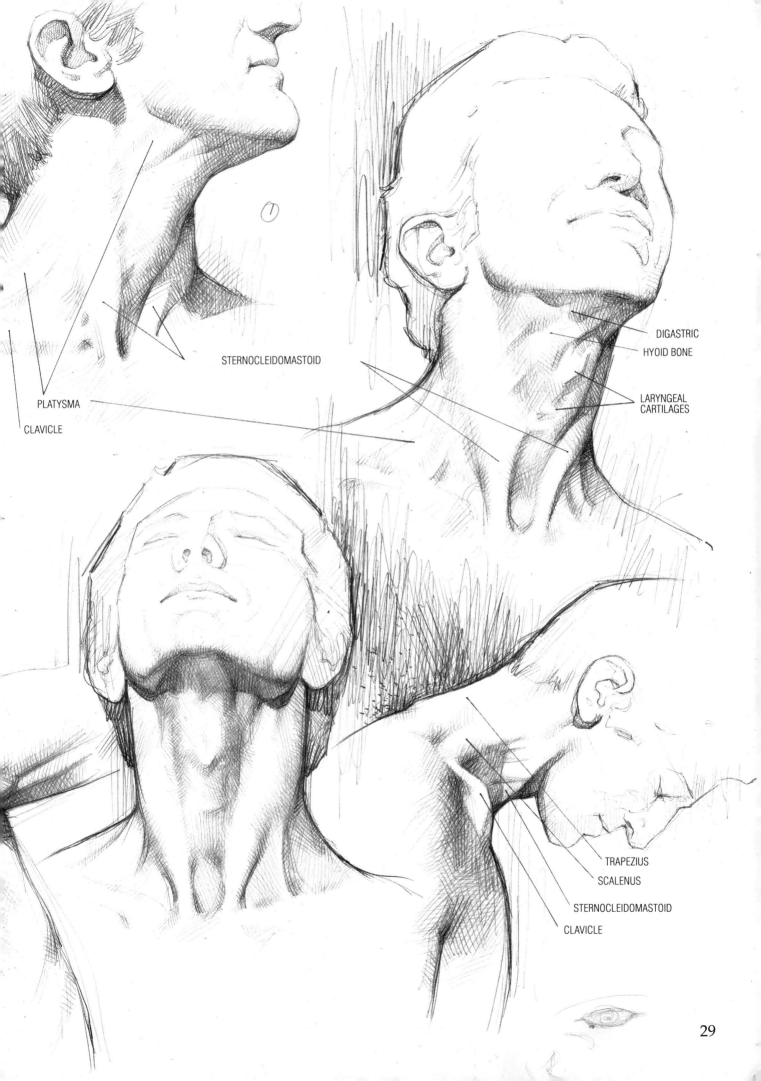

STERNOCLEIDOMASTOID

PLATYSMA

CLAVICLE

DIGASTRIC

HYOID BONE

LARYNGEAL
CARTILAGES

TRAPEZIUS

SCALENUS

STERNOCLEIDOMASTOID

CLAVICLE

SUPERIOR HYOIDAL MUSCLES

DIGASTRIC o: a double-bellied muscle: posterior belly, from mastoid process; anterior belly, from maxilla, behind chin (e.g. see illustrations pp. 12–13)
i: hyoid bone (to which the double bellies are fastened by a tendinous loop)
a: opens the mouth, raises hyoid and tongue

STYLOHYOID o: temporal bone (styloid process)
i: hyoid bone (lateral border)
a: raises hyoid bone

MYLOHYOID
GENIOHYOID o: forms floor of mouth and canopy of chin at front
i: hyoid bone
a: raises floor of mouth

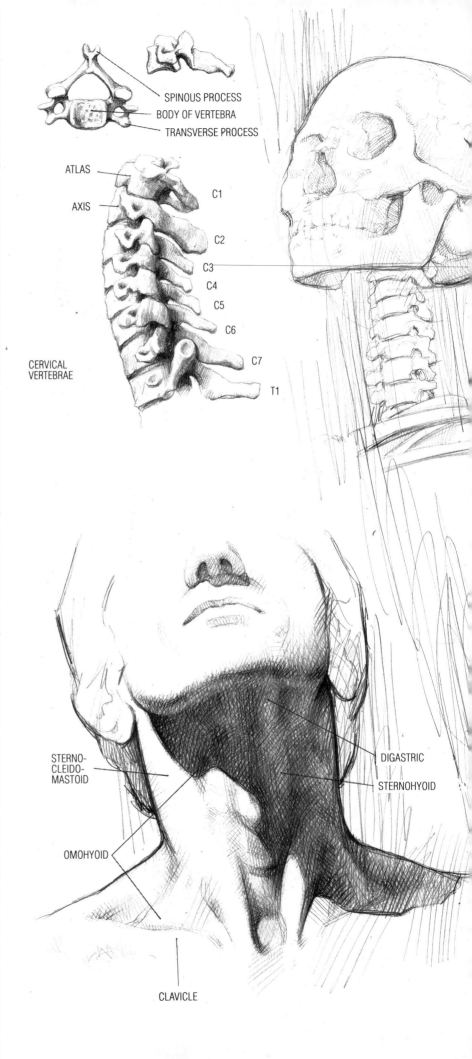

SPINOUS PROCESS
BODY OF VERTEBRA
TRANSVERSE PROCESS

ATLAS

AXIS

C1
C2
C3
C4
C5
C6
C7
T1

CERVICAL VERTEBRAE

STERNO-CLEIDO-MASTOID

OMOHYOID

DIGASTRIC

STERNOHYOID

CLAVICLE

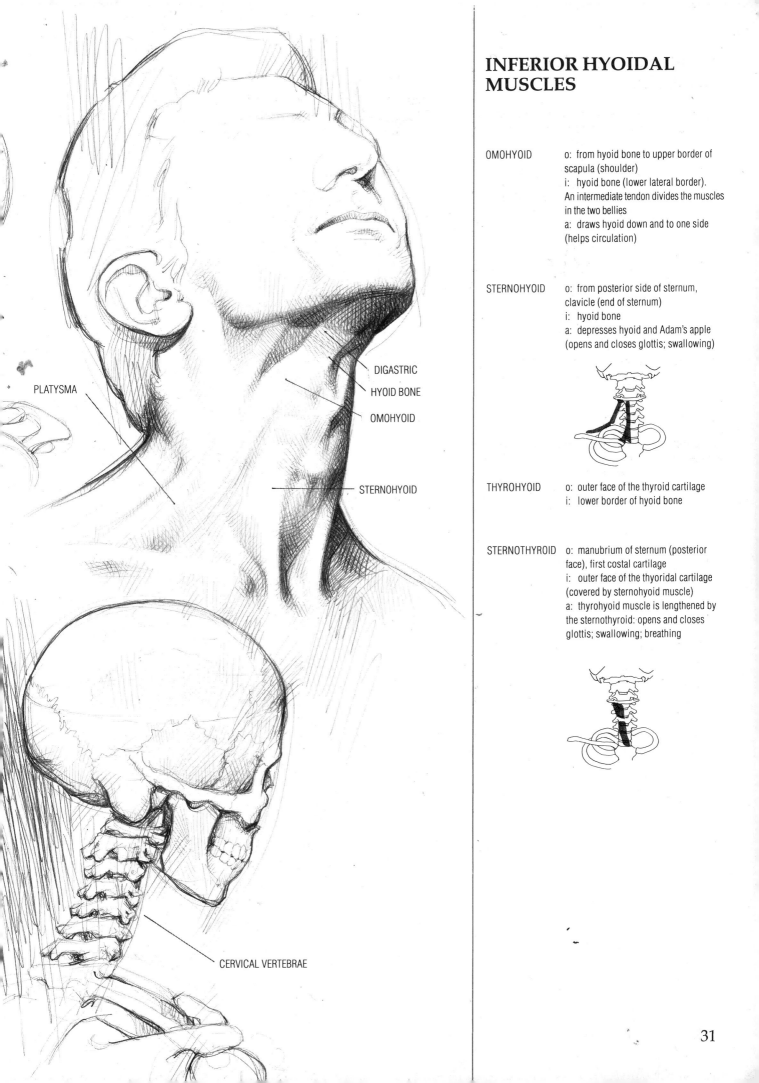

INFERIOR HYOIDAL MUSCLES

PLATYSMA

DIGASTRIC

HYOID BONE

OMOHYOID

STERNOHYOID

CERVICAL VERTEBRAE

OMOHYOID o: from hyoid bone to upper border of scapula (shoulder)
i: hyoid bone (lower lateral border). An intermediate tendon divides the muscles in the two bellies
a: draws hyoid down and to one side (helps circulation)

STERNOHYOID o: from posterior side of sternum, clavicle (end of sternum)
i: hyoid bone
a: depresses hyoid and Adam's apple (opens and closes glottis; swallowing)

THYROHYOID o: outer face of the thyroid cartilage
i: lower border of hyoid bone

STERNOTHYROID o: manubrium of sternum (posterior face), first costal cartilage
i: outer face of the thyoridal cartilage (covered by sternohyoid muscle)
a: thyrohyoid muscle is lengthened by the sternothyroid: opens and closes glottis; swallowing; breathing

TRUNK MUSCLES

The trunk, with the head and neck, forms the largest part of the human body and is subdivided into an upper part (the thorax) and a lower section (the abdomen), to which two visceral cavities correspond, separated by the diaphragm. The bony framework of the thorax is attached to the spinal column, in turn subdivided into cervical, dorsal and lumbar vertebrae, ending in the sacrum (five pieces) and the coccyx (four pieces). The vertebral complex, consisting of the articulations and vertebral ligaments and related muscles, is called the spine.

The conical thoracic cage, slightly flattened in front, is wider at the base, near the abdomen; it is formed by twelve pairs of ribs (and their associated cartilages), articulating at the back with the spine, except for the last two very short ribs (called floating ribs). The cartilage of the upper seven pairs of ribs (called true ribs) articulates at the front with the sternum. The intrinsic thoracic (respiratory) muscles are conspicuous, and the group of dorsal and thoracic muscles connected to the shoulder girdle are related to the upper limb, whose movement they determine.

The abdominal section is ovoid in shape and is enclosed, at the base by the pelvis, at the back by the lumbar tract of the spine, at the sides and in front by the broad muscular laminae and connective fascia which together make up the abdominal wall, the state of tension of which determines the individual conformation of the region.

Iliocostalis

o: iliac crest and dorsal fascia of sacrum
i: costal angle of 12th to 5th ribs, sometimes to transverse process of cervical vertebrae
a: extends and slightly rotates spinal column

Longissimus

o: dorsal fascia of sacrum and successive regions, spinous apophysis of lumbar vertebrae, transverse apophysis of thoracic and cervical vertebrae
i: transverse vertebral process to mastoid process of temporal
a: stretches the spine

Spinalis

o: (three sections: the back, the neck, the head); spinous process of the cervical and thoracic vertebrae
i: adjacent spinous process
a: extends spine, bends slightly sideways

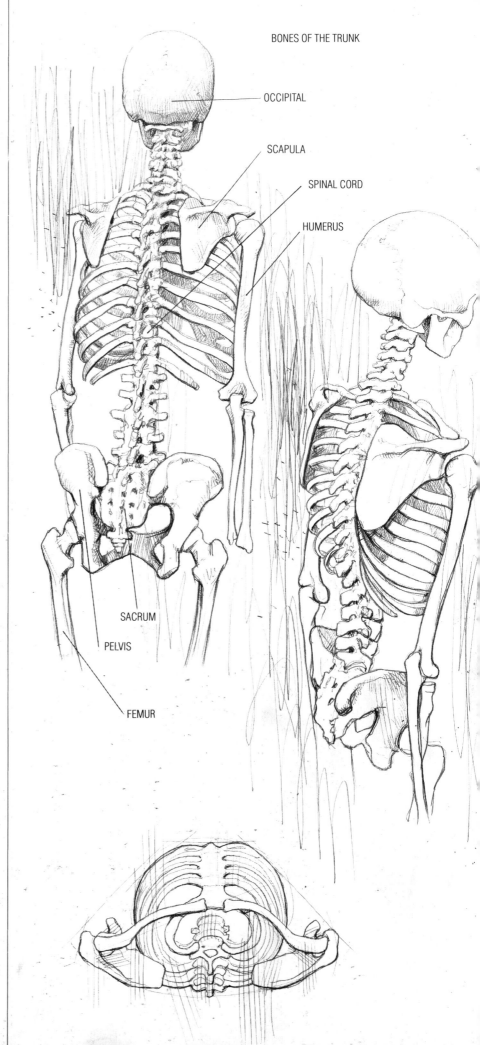

BONES OF THE TRUNK

OCCIPITAL

SCAPULA

SPINAL CORD

HUMERUS

SACRUM

PELVIS

FEMUR

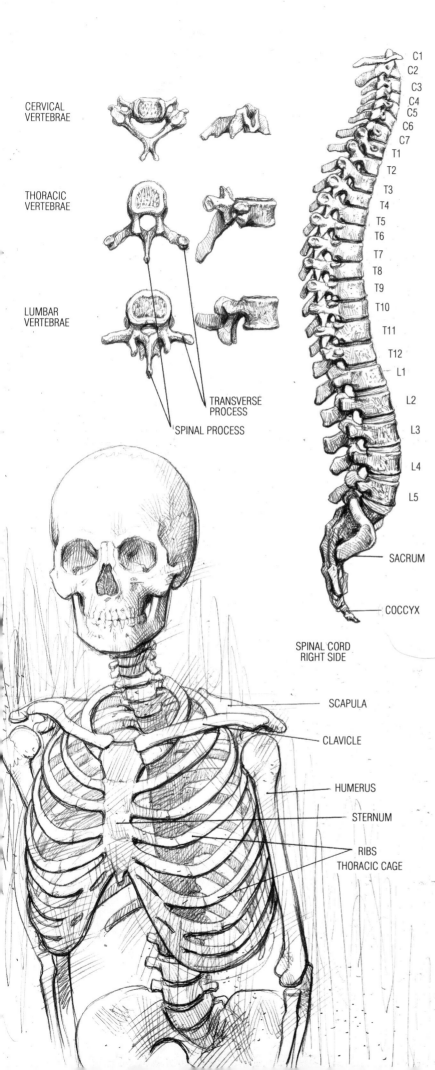

CERVICAL
VERTEBRAE

THORACIC
VERTEBRAE

LUMBAR
VERTEBRAE

TRANSVERSE
PROCESS

SPINAL PROCESS

C1
C2
C3
C4
C5
C6
C7
T1
T2
T3
T4
T5
T6
T7
T8
T9
T10
T11
T12
L1
L2
L3
L4
L5

SACRUM

COCCYX

SPINAL CORD
RIGHT SIDE

SCAPULA

CLAVICLE

HUMERUS

STERNUM

RIBS
THORACIC CAGE

Splenius Muscles of Neck

o: spinous process from 3rd to 6th thoracic vertebrae: a broad muscle on either side of neck and upper part of chest
i: transverse process from 3rd to 1st cervical vertebrae
a: draws neck and head backwards and helps to turn head to one side

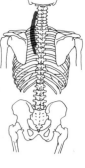

Splenius Muscles of Head

o: spinous process from 3rd to 6th cervical vertebrae and from 1st to 3rd thoracic vertebrae
i: occipital (superior nuchal line), temporal (mastoid process)
a: draws head backwards and turns it from side to side

Semispinalis

o: transverse process of thoracic and last cervical vertebrae
i: spinous process of first six thoracic vertebrae and last cervical, occipital (nuchal line)

Rotatores Muscles

o: transverse process of the lumbar, thoracic, cervical vertebrae
i: spinous process of connecting vertebrae

The semispinalis, multifidus and rotatores muscles are grouped under the TRANSVERSOSPINALIS muscles, the complex action of which extends spinal column and head, with slight rotation and sideways bending.

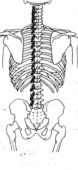

Multifidus

o: sacrum (dorsal fascia), transverse process of the lumbar, thoracic and last cervical vertebrae
i: spinous process of lumbar, thoracic and adjacent cervical vertebrae

Sacrococcygeus

These are rudimentary muscle bundles on the ventral side of the sacrum and coccyx, and are irrelevant both to action and to art.

Interspinales Muscles

Intertransverse Muscles

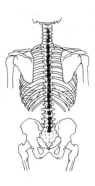 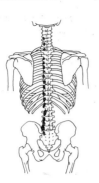

o and i: between a spinous process and the length of the spine

a: stretches the back

o and i: between the transverse process of the next vertebrae

a: bends the spine to the side

Suboccipital Muscles

These are four short muscles in the nuchal region:

RECTUS CAPITIS POSTERIOR MINOR
o: posterior tubercle of atlas
(1st cervical vertebra)
i: occipital (inferior nuchal line)

RECTUS CAPITIS POSTERIOR MAJOR
o: spinous process of axis
(2nd cervical vertebra)
i: occipital (inferior nuchal line)

OBLIQUUS CAPITIS INFERIOR
o: spinous process of axis
i: transverse process of atlas

OBLIQUUS CAPITIS SUPERIOR
o: transverse process of atlas
i: occipital (inferior nuchal line)

The suboccipital muscles share the same function of extending, bending sideways and rotating the head.

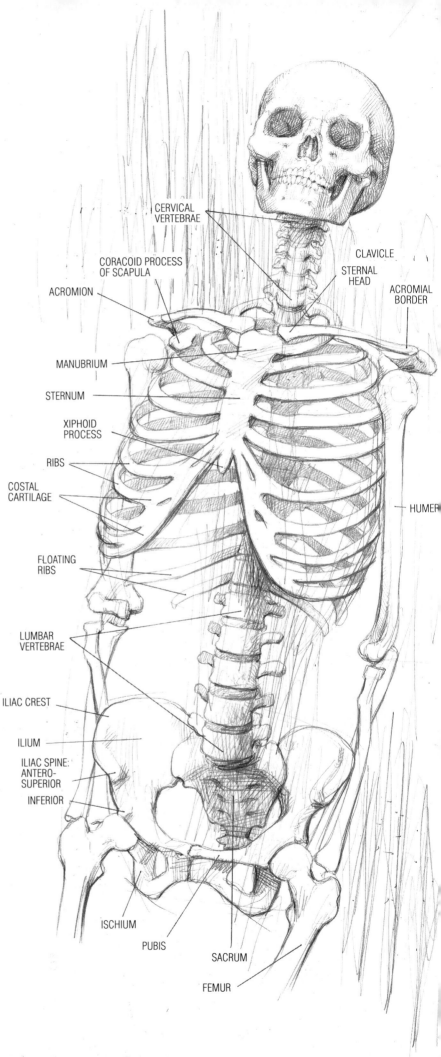

CERVICAL VERTEBRAE

CLAVICLE

CORACOID PROCESS OF SCAPULA

STERNAL HEAD

ACROMION

ACROMIAL BORDER

MANUBRIUM

STERNUM

XIPHOID PROCESS

RIBS

COSTAL CARTILAGE

HUMER

FLOATING RIBS

LUMBAR VERTEBRAE

ILIAC CREST

ILIUM

ILIAC SPINE:
ANTERO-SUPERIOR

INFERIOR

ISCHIUM

PUBIS

SACRUM

FEMUR

Longus Cervicis
(Long Muscle of the Neck)

o: anterior vertebral muscle of the first three thoracic and last cervical vertebrae, transverse process of the cervical vertebrae
i: anterior tubercle of atlas, body of superior cervical vertebrae
a: bends and rotates the head

Longus Capitis
(Long Muscle of the Head)

o: fascia: anterior tubercle of the transverse process from 3rd to 6th cervical vertebrae
i: body of occipital tubercle of the pharynx
a: bending of head and cervical tract, sideways bending, rotation

Rectus Capitis Anterior Muscle
Rectus Capitis Lateralis Muscle

o: transverse process of atlas
i: body of occipital bone
a: bending and sideways inclining of head

The muscles listed here relating to the head are arranged around the vertebral column or in deep layers, but are not directly noticeable in external morphological observation. They are, however, very important in helping the movements of the trunk (besides participating in walking and staying upright) and, therefore, for all the actions that derive from them.

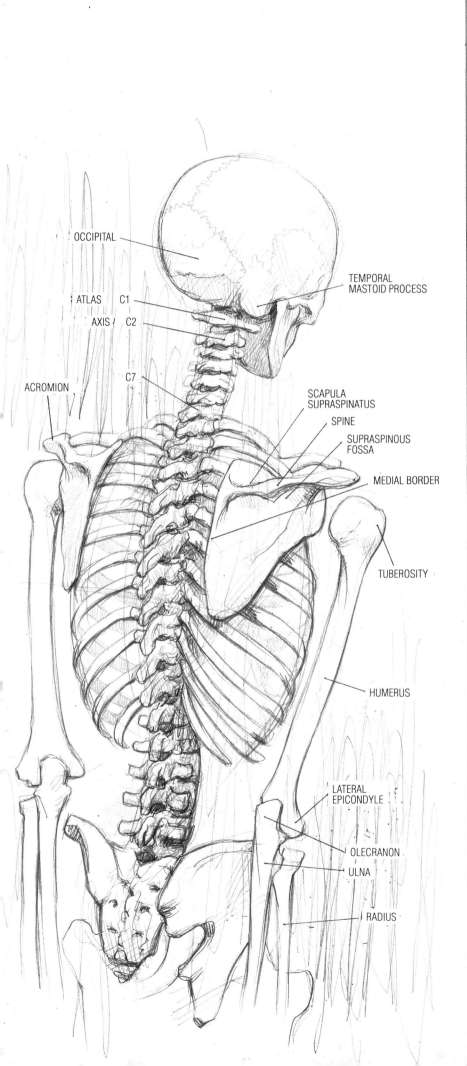

OCCIPITAL

TEMPORAL
MASTOID PROCESS

ATLAS C1

AXIS C2

C7

ACROMION

SCAPULA
SUPRASPINATUS

SPINE

SUPRASPINOUS
FOSSA

MEDIAL BORDER

TUBEROSITY

HUMERUS

LATERAL
EPICONDYLE

OLECRANON

ULNA

RADIUS

Pectoralis Major

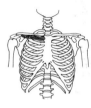

o: inner half of clavicle, sternum, manubrium and anterior fascia of the sternum, costal cartilages from 2nd to 6th ribs, fascia of abdominal muscles
i: humerus
a: adduction (draws arm downwards and forwards, raises it up), hoists trunk (climbing movement), moves the upper limbs towards centre

Subclavian Muscle

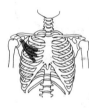

o: cartilage of 1st rib
i: clavicle (inferior fascia)
a: fastening of clavicle in sternoclavicular articulation

Pectoralis Minor

o: 3rd, 4th and 5th ribs (external fascia) to coracoid process
i: scapula (apex of coracoid process)
a: depresses point of shoulder, lifts ribs (breathing)

Serratus Anterior

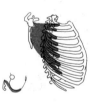

o: lateral fascia of the upper nine ribs
i: scapula (spinal edge; upper angle; median fascia; medial margin; inferior fascia; lower angle)
a: pulls shoulder blade forwards (with sideways and forward traction); raises ribs (inhaling)

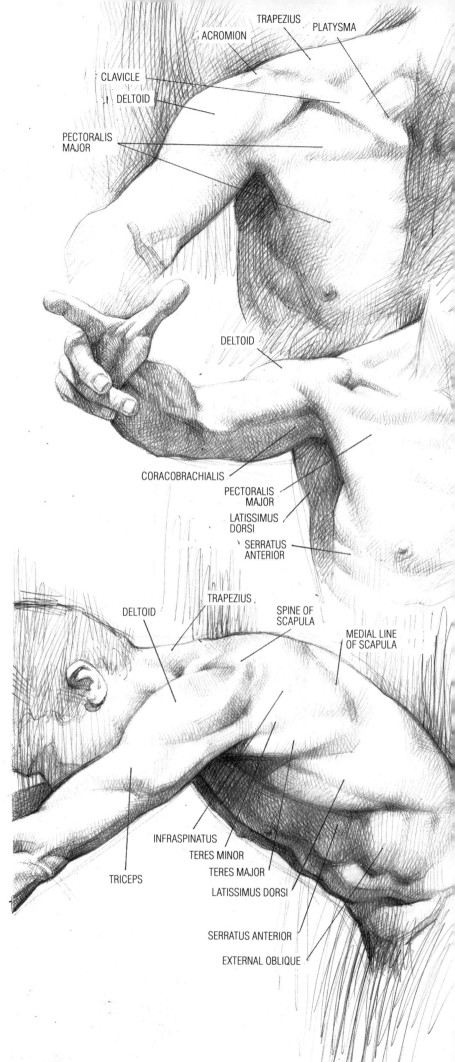

TRAPEZIUS
PLATYSMA
ACROMION
CLAVICLE
DELTOID
PECTORALIS MAJOR
DELTOID
CORACOBRACHIALIS
PECTORALIS MAJOR
LATISSIMUS DORSI
SERRATUS ANTERIOR
TRAPEZIUS
DELTOID
SPINE OF SCAPULA
MEDIAL LINE OF SCAPULA
INFRASPINATUS
TERES MINOR
TERES MAJOR
LATISSIMUS DORSI
TRICEPS
SERRATUS ANTERIOR
EXTERNAL OBLIQUE

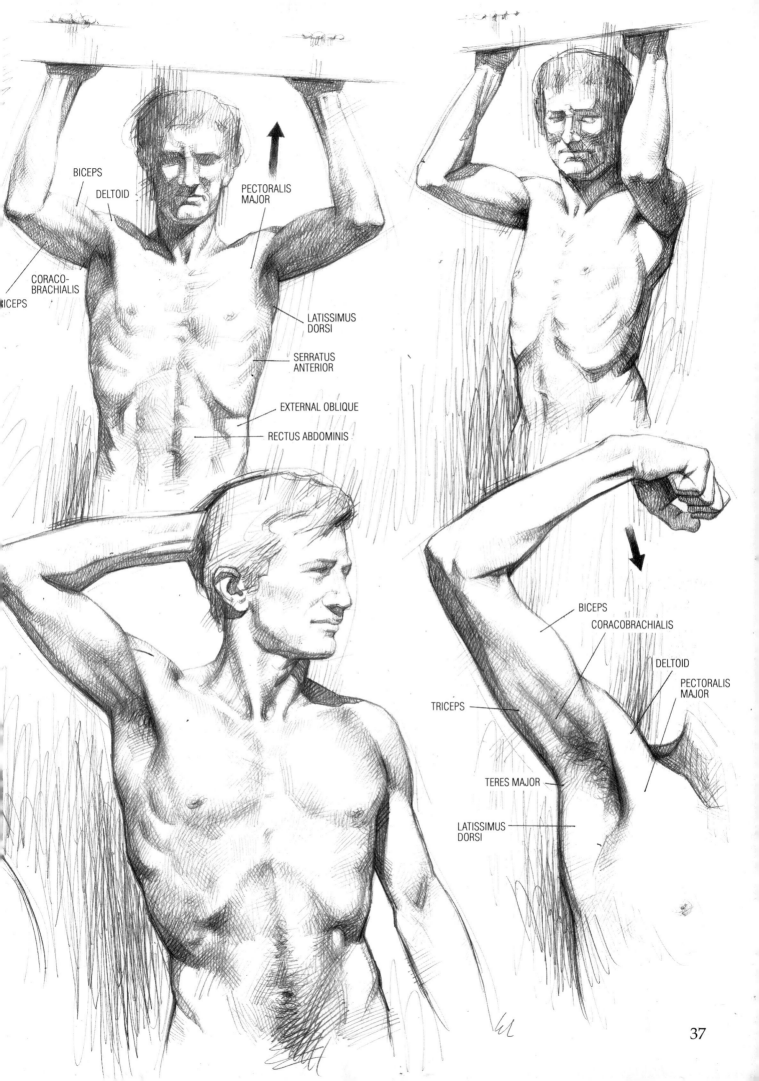

BICEPS

DELTOID

CORACO-
BRACHIALIS

TRICEPS

PECTORALIS
MAJOR

LATISSIMUS
DORSI

SERRATUS
ANTERIOR

EXTERNAL OBLIQUE

RECTUS ABDOMINIS

BICEPS

CORACOBRACHIALIS

DELTOID

PECTORALIS
MAJOR

TRICEPS

TERES MAJOR

LATISSIMUS
DORSI

37

Trapezius

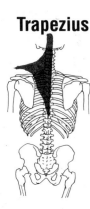

o: occipital bone (nape ligament), spinous processes from 1st cervical to 12th thoracic vertebra
i: scapula (acromion, spine and ridge of shoulder blade), clavicle
a: extends and rotates head, elevates shoulder and rotates shoulder blade, hoists trunk (climbing)

Pectoralis Major

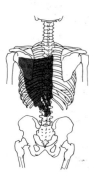

o: spinous processes from 6th to 12th thoracic vertebrae; lumbar vertebrae, sacrum and posterior iliac crest (through the lumbar–dorsal fascia)
i: humerus (medially, bicipital sulcus)
a: draws arm down and forwards from the shoulder, hoists trunk (climbing movement) with bending of the lumbar column and movement in front of the pelvis

Levator Scapulae

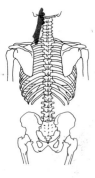

o: transverse processes of first four cervical vertebrae
i: scapula (upper angle, vertebral edge)
a: raises angle of shoulder blade, lifts shoulder, slight extension of the neck

Rhomboid (Major and Minor)

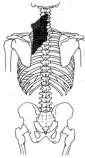

o: spinous processes of the first four thoracic vertebrae and the last two cervical
i: medial margin of the scapula
a: medial traction and high up on scapula, fastening it during movements of the limb

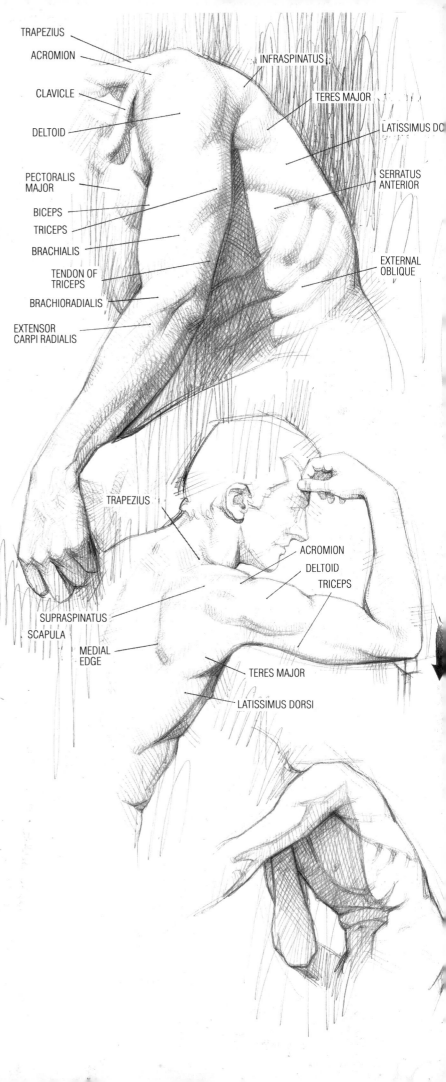

TRAPEZIUS
ACROMION
CLAVICLE
DELTOID
PECTORALIS MAJOR
BICEPS
TRICEPS
BRACHIALIS
TENDON OF TRICEPS
BRACHIORADIALIS
EXTENSOR CARPI RADIALIS

INFRASPINATUS
TERES MAJOR
LATISSIMUS DO
SERRATUS ANTERIOR
EXTERNAL OBLIQUE

TRAPEZIUS
SUPRASPINATUS
SCAPULA
MEDIAL EDGE
ACROMION
DELTOID
TRICEPS
TERES MAJOR
LATISSIMUS DORSI

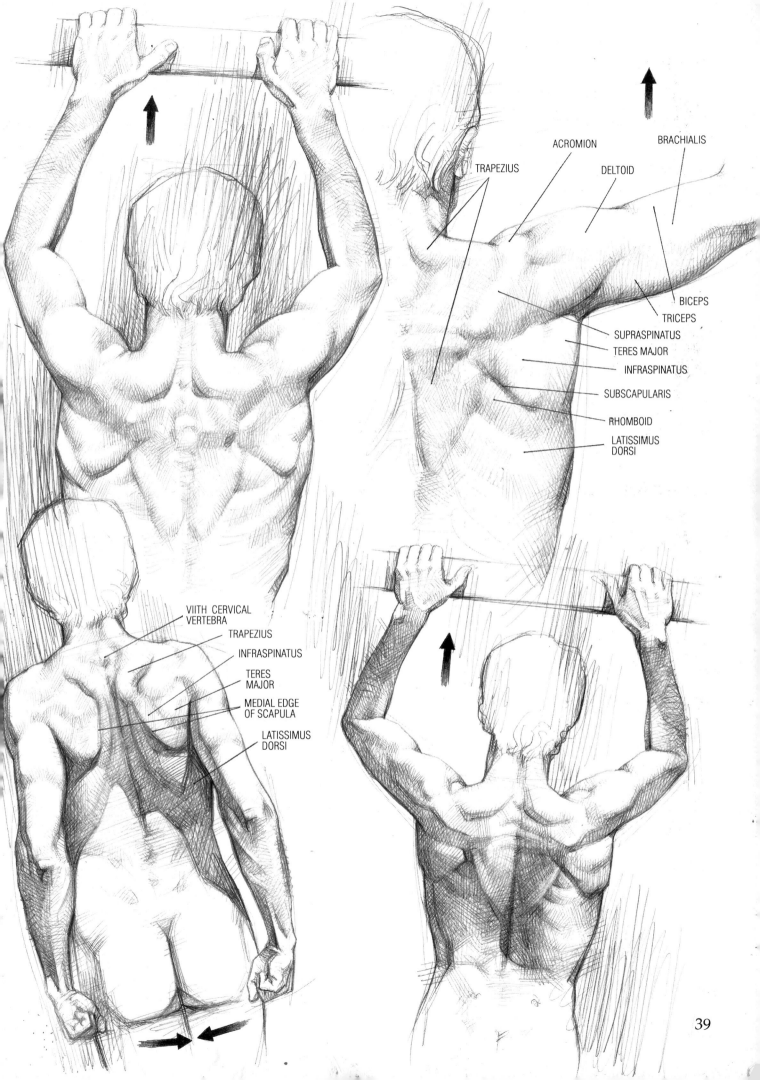

ACROMION

BRACHIALIS

TRAPEZIUS

DELTOID

BICEPS

TRICEPS

SUPRASPINATUS

TERES MAJOR

INFRASPINATUS

SUBSCAPULARIS

RHOMBOID

LATISSIMUS
DORSI

VIITH CERVICAL
VERTEBRA

TRAPEZIUS

INFRASPINATUS

TERES
MAJOR

MEDIAL EDGE
OF SCAPULA

LATISSIMUS
DORSI

39

Intercostal Muscles (Internal and External)

These close the intervals between the ribs and stretch between the internal and external margins of adjacent ribs, ending before reaching the vertebrae.

Levatores Costarum

Each levatores costarum muscle passes from the tip of the transverse process of one thoracic vertebra to the rib below the tubercle (vertebral tract and neck), and acts in breathing.

Subcostal Muscles
Transversus Thoracis

Found on internal face of ribs; function concerns respiratory movement.

Serratus Posterior Superior

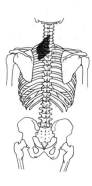

o: spinous processes of last two cervical and first three thoracic vertebrae
i: outer dorsal face of ribs from the 2nd to the 5th
a: breathing (lifting of ribs)

Serratus Posterior Inferior

o: spinous processes from the 11th thoracic vertebra to the 2nd lumbar
i: lower posterior margins of last four ribs
a: exhalation (lowering of ribs)

Diaphragm Muscle

Dome-shaped muscle lamina, the fascia originating in the lumbar, costal and sternal regions, meeting at the phrenic centre; separates thoracic cavity from abdomen; mainly visceral action.

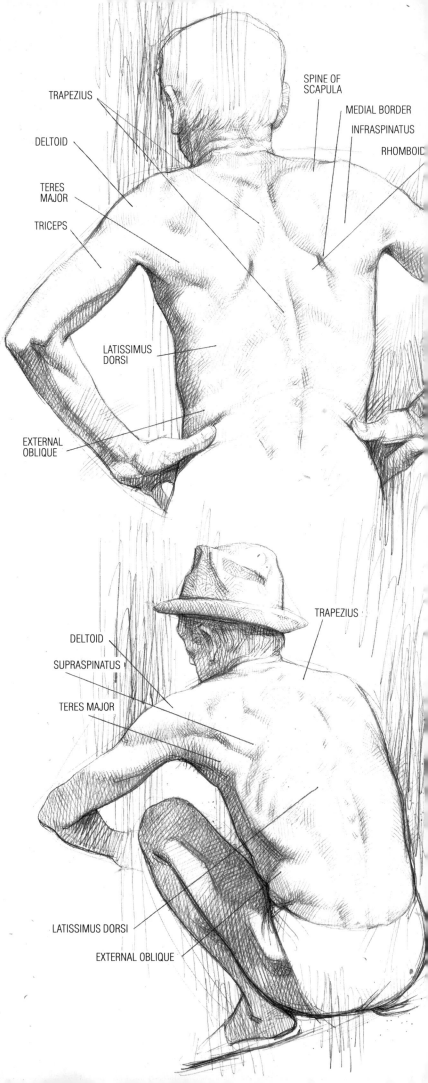

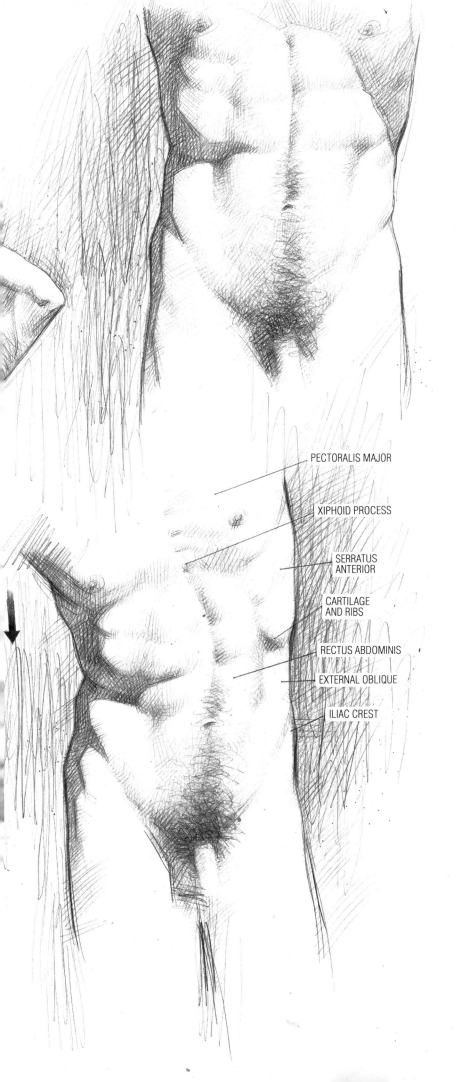

Quadratus Lumborum

o: iliac crest (posterior tract, inner margin)
i: 12th rib, costiform process of the lumbar vertebrae
a: lateral folding of the spinal column and the thoracic cage

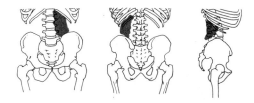

Rectus Abdominis

This is formed by two separate parallel muscles on the medial plane from the symphysis pubis to rib cartilages. Other abdominal muscles are inserted into its fibrous covering.

o: costal cartilages from the 5th, 6th and 7th ribs, sternum (anterior)
i: symphysis pubis
a: flexes thorax, raises the pelvis and lowers limbs, containment of the abdominal viscera

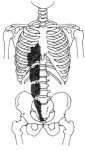

Pyramidalis

o: symphysis pubis (in front of the insertion of the rectus)
i: linea alba
a: tension of the linea alba

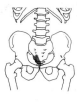

PECTORALIS MAJOR

XIPHOID PROCESS

SERRATUS ANTERIOR

CARTILAGE AND RIBS

RECTUS ABDOMINIS

EXTERNAL OBLIQUE

ILIAC CREST

External Oblique

o: from 5th to 12th rib (lateral face, with eight digitations)
i: iliac crest (outer margin), pubis and sheath of rectus abdominis (with broad tendon)
a: flexes thorax, raises pelvis

Internal Oblique

o: iliac crest (inner margin), lumbar fascia, pubis
i: ribs (costal cartilage from 7th, 8th and 9th, lower margin of 10th, 11th and 12th), sheath of rectus abdominis
a: flexes side of thorax

Transversus Abdominis

o: ribs (inner fascia, anterior tract of last six), lumbar fascia, iliac crest (inner margin), pubis
i: sheath of rectus abdominis
a: tension of the abdominal wall, compression of the abdomen

Muscles of the Perineum

These are a collection of muscles around and below the pelvis, including the anal muscle, the urogenital muscles, etc. They are of no importance in art.

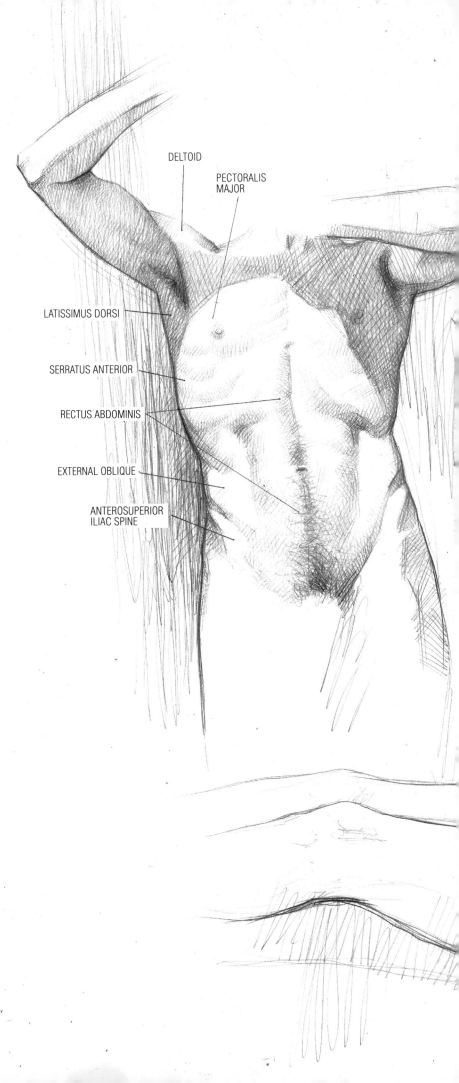

DELTOID

PECTORALIS MAJOR

LATISSIMUS DORSI

SERRATUS ANTERIOR

RECTUS ABDOMINIS

EXTERNAL OBLIQUE

ANTEROSUPERIOR ILIAC SPINE

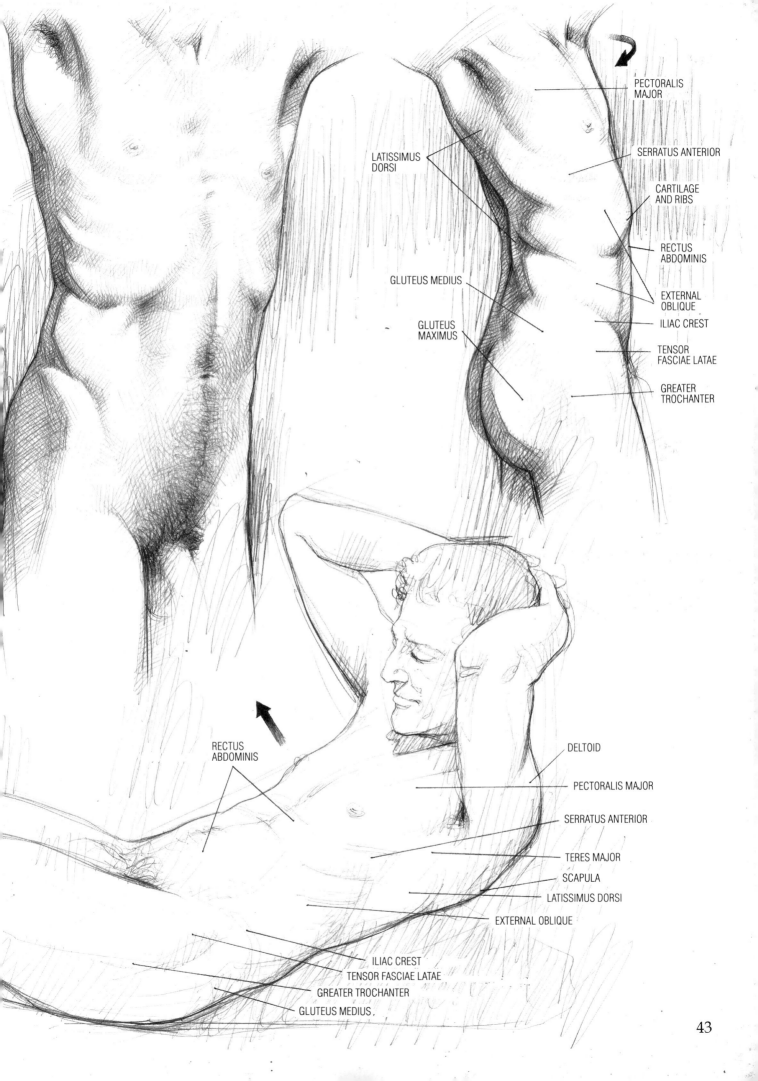

PECTORALIS
MAJOR

SERRATUS ANTERIOR

CARTILAGE
AND RIBS

RECTUS
ABDOMINIS

EXTERNAL
OBLIQUE

ILIAC CREST

TENSOR
FASCIAE LATAE

GREATER
TROCHANTER

LATISSIMUS
DORSI

GLUTEUS MEDIUS

GLUTEUS
MAXIMUS

RECTUS
ABDOMINIS

DELTOID

PECTORALIS MAJOR

SERRATUS ANTERIOR

TERES MAJOR

SCAPULA

LATISSIMUS DORSI

EXTERNAL OBLIQUE

ILIAC CREST

TENSOR FASCIAE LATAE

GREATER TROCHANTER

GLUTEUS MEDIUS

UPPER LIMB MUSCLES

The upper limb is made up of a free part (specifically the arm, forearm and hand) and it articulates with the shoulder girdle (scapula, clavicle) at the level of the shoulder.

The arm is a flattened cylinder on the lateral plane, with the muscles arranged round the humerus in two groups: anterior (flexor) and posterior (extensor)

The shape of the forearm is a cone flattened in the front–back direction. The muscles around the ulna (medially placed) and the radius (laterally) are flexors (anterior cavity) with the fleshy mass beside the articulation of the elbow, and the thin tendinous part near the wrist (containing the ligaments of the carpus).

The hand is flattened, complex in form due to the presence of many bones (carpus, metacarpus, phalanges). Only the palm shows muscles, covered by the palmar fascia; on the back, only the sheathed tendons of the extensor muscles are visible.

The upper limb, apart from characteristic movements of pronation and supination of the forearm, presents numerous articulations with great freedom of movement (and consequently orientation of the axes of the segments) which must be taken into consideration in making artistic representations.

Deltoid Muscle

o: clavicle (collar bone), scapula (acromion and spine, lower margin)
i: humerus (outside edge)
a: abduction of the arm (contraction of the inner muscle), draws humerus backwards and forwards (contraction of anterior fascia); dorsal and medial movement (contraction of the posterior fascia)

Subscapularis

o: scapula (costal side)
i: humerus (top, front, small tuberosity)
a: rotates the arm medially

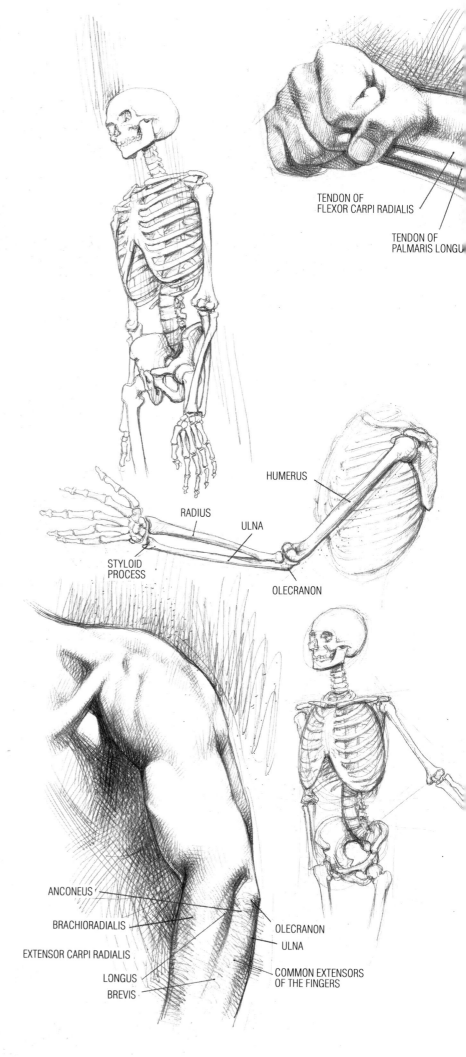

TENDON OF FLEXOR CARPI RADIALIS

TENDON OF PALMARIS LONGU

HUMERUS

RADIUS

ULNA

STYLOID PROCESS

OLECRANON

ANCONEUS

BRACHIORADIALIS

EXTENSOR CARPI RADIALIS

LONGUS

BREVIS

OLECRANON

ULNA

COMMON EXTENSORS OF THE FINGERS

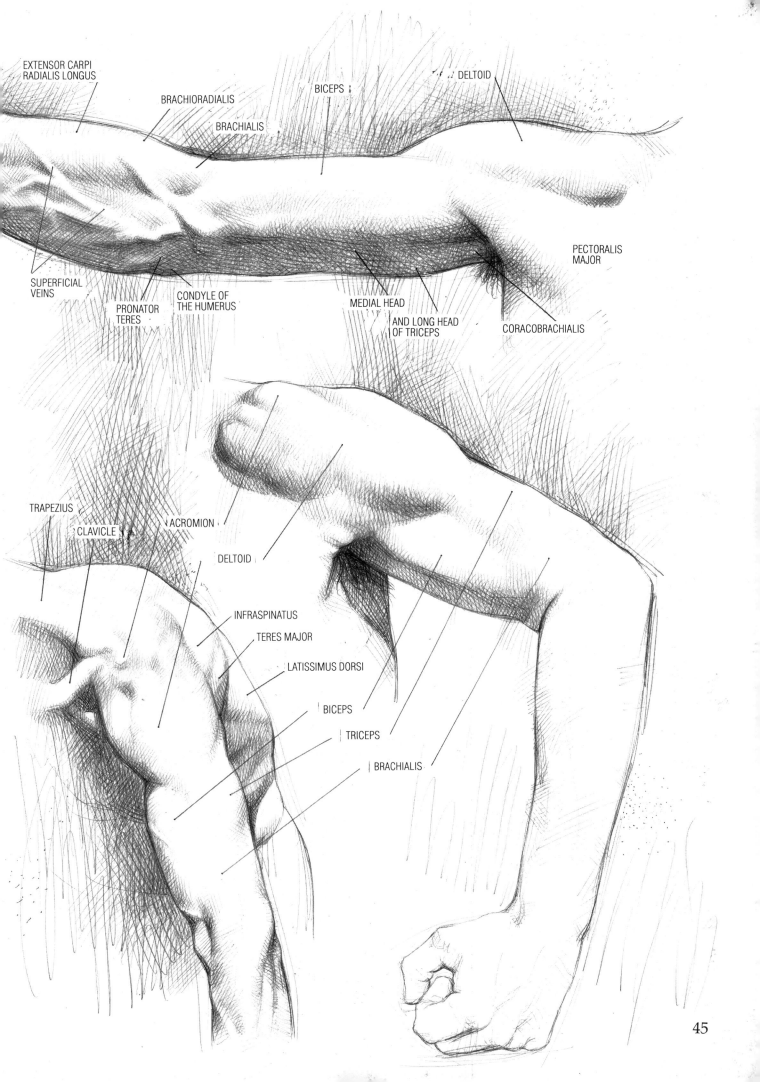

EXTENSOR CARPI
RADIALIS LONGUS

BRACHIORADIALIS

BRACHIALIS

BICEPS

DELTOID

PECTORALIS
MAJOR

SUPERFICIAL
VEINS

PRONATOR
TERES

CONDYLE OF
THE HUMERUS

MEDIAL HEAD

AND LONG HEAD
OF TRICEPS

CORACOBRACHIALIS

TRAPEZIUS

CLAVICLE

ACROMION

DELTOID

INFRASPINATUS

TERES MAJOR

LATISSIMUS DORSI

BICEPS

TRICEPS

BRACHIALIS

45

Supraspinatus

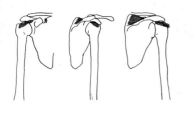

o: scapula (supraspinous fossa)
i: humerus (upper condyle, anterior face; large tuberosity)
a: rotates arm outwards, abduction

Infraspinatus

o: scapula (infraspinatus, back)
i: humerus (upper condyle, posterior face; large tuberosity)
a: rotates arm outwards and backwards

Teres Minor

o: scapula (dorsal side, to inner tubercle of humerus)
i: humerus (upper condyle, posterior face, large tubercle)
a: draws humerus outwards and rotates arm backwards, adduction

Teres Major

o: scapula (from lower corner of scapula to front of humerus)
i: humerus (upper condyle, anterior face)
a: draws humerus outwards and rotates backwards

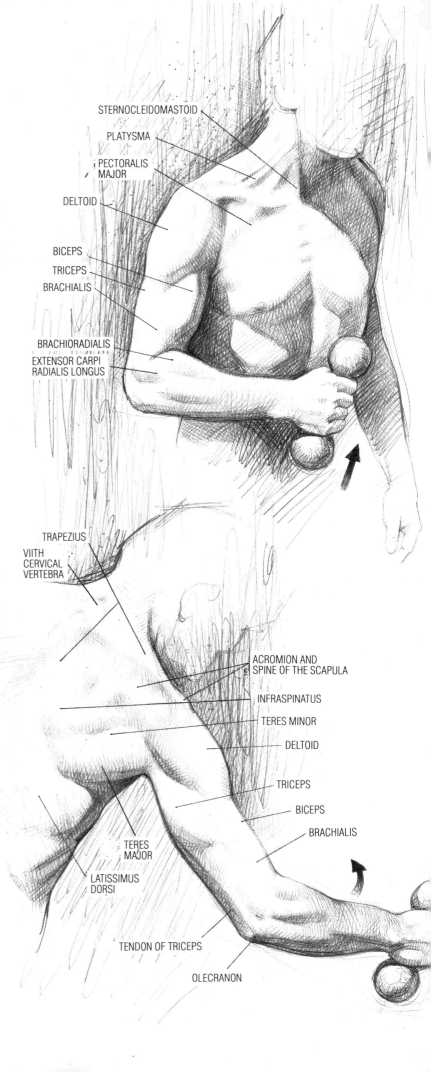

STERNOCLEIDOMASTOID
PLATYSMA
PECTORALIS MAJOR
DELTOID
BICEPS
TRICEPS
BRACHIALIS
BRACHIORADIALIS
EXTENSOR CARPI RADIALIS LONGUS
TRAPEZIUS
VIITH CERVICAL VERTEBRA
ACROMION AND SPINE OF THE SCAPULA
INFRASPINATUS
TERES MINOR
DELTOID
TRICEPS
BICEPS
BRACHIALIS
TERES MAJOR
LATISSIMUS DORSI
TENDON OF TRICEPS
OLECRANON

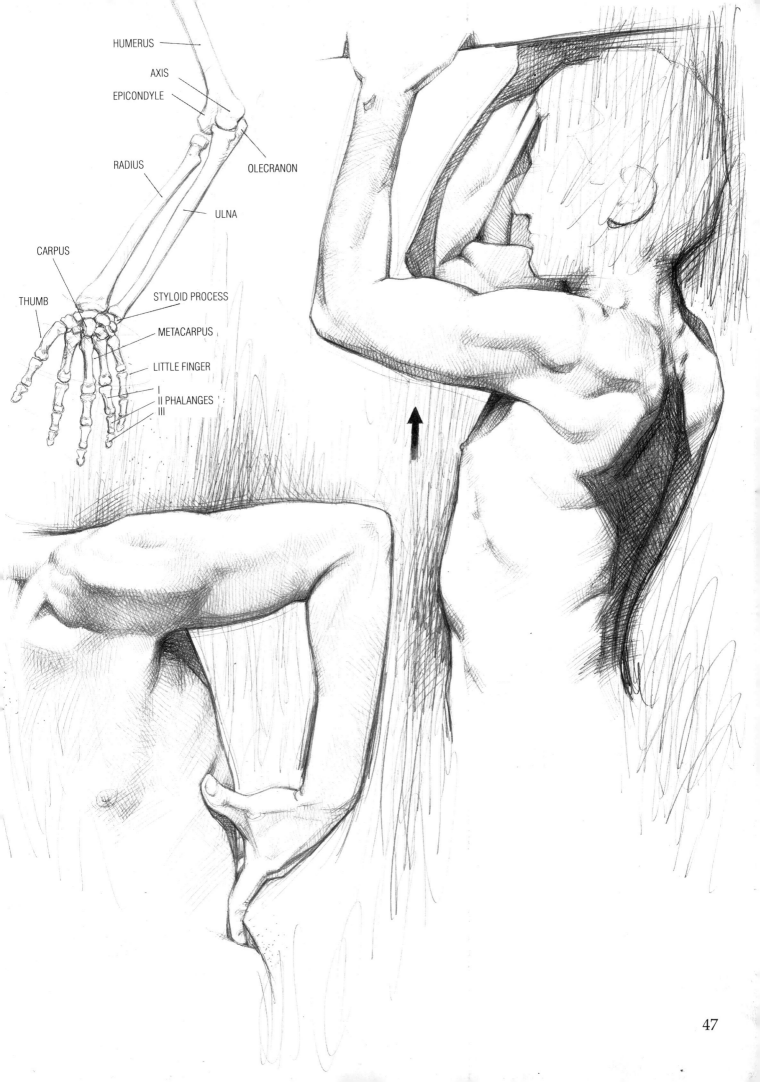

HUMERUS

AXIS

EPICONDYLE

OLECRANON

RADIUS

ULNA

CARPUS

THUMB

STYLOID PROCESS

METACARPUS

LITTLE FINGER

I
II PHALANGES
III

47

Biceps

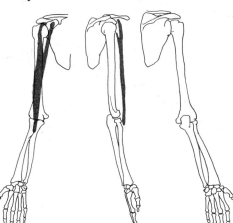

o: short head: scapula (coracoid
process with short tendons);
long head: scapula (glenoid cavity
(under acromion) with long tendons)
i: radius (tubercle)
a: flexes forearm, rotates radius
outwards, depresses shoulder blade

Coracobrachialis

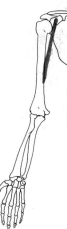

o: scapula (coracoid process)
i: humerus (inner side, half-way down)
a: draws arm forwards and sideways,
rotates outwards

Brachialis

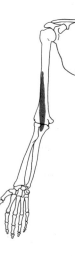

o: humerus (front, lower half)
i: ulna (coronoidal process), articular
capsule of elbow
a: flexes forearm

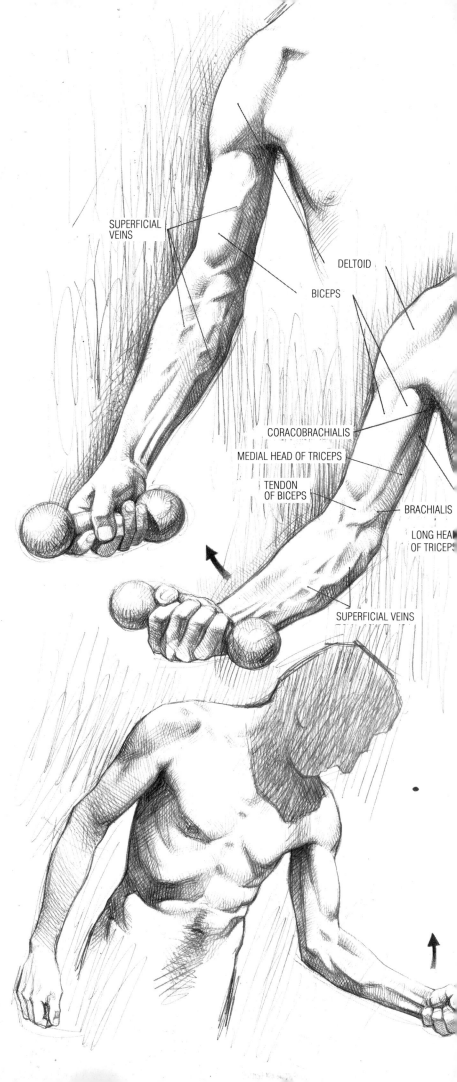

SUPERFICIAL
VEINS

DELTOID

BICEPS

CORACOBRACHIALIS

MEDIAL HEAD OF TRICEPS

TENDON
OF BICEPS

BRACHIALIS

LONG HEAD
OF TRICEPS

SUPERFICIAL VEINS

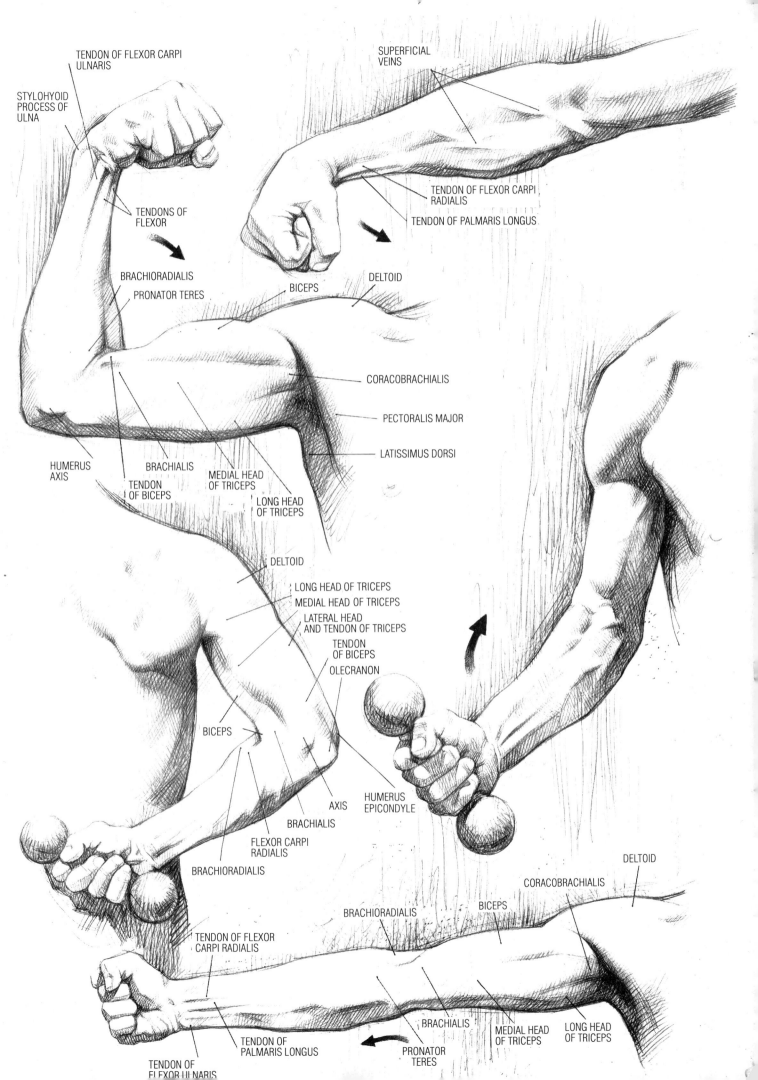

STYLOHYOID
PROCESS OF
ULNA

TENDON OF FLEXOR CARPI
ULNARIS

SUPERFICIAL
VEINS

TENDONS OF
FLEXOR

TENDON OF FLEXOR CARPI
RADIALIS

TENDON OF PALMARIS LONGUS

BRACHIORADIALIS

PRONATOR TERES

BICEPS

DELTOID

CORACOBRACHIALIS

PECTORALIS MAJOR

LATISSIMUS DORSI

HUMERUS
AXIS

BRACHIALIS

MEDIAL HEAD
OF TRICEPS

TENDON
OF BICEPS

LONG HEAD
OF TRICEPS

DELTOID

LONG HEAD OF TRICEPS

MEDIAL HEAD OF TRICEPS

LATERAL HEAD
AND TENDON OF TRICEPS

TENDON
OF BICEPS

OLECRANON

BICEPS

AXIS

BRACHIALIS

FLEXOR CARPI
RADIALIS

HUMERUS
EPICONDYLE

BRACHIORADIALIS

TENDON OF FLEXOR
CARPI RADIALIS

BRACHIORADIALIS

BICEPS

CORACOBRACHIALIS

DELTOID

BRACHIALIS

MEDIAL HEAD
OF TRICEPS

LONG HEAD
OF TRICEPS

PRONATOR
TERES

TENDON OF
PALMARIS LONGUS

TENDON OF
FLEXOR ULNARIS

Triceps

o: long head: scapula (below socket to olecranon process of ulna)
i: lateral head: humerus (back of humerus, above musculospinal group); medial (or deep) head: humerus (shoulder blade below socket to olecranon process of ulna)
i: ulna (olecranon), with broad tendon
a: extends forearm

Anconeus

o: humerus (back of lateral epicondyle)
i: ulna (to outer side of ulna)
a: extends forearm

Pronator Teres

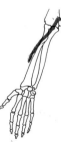

o: humerus (internal condyle, fascia of forearm), ulna (coronoid process)
i: radius (outer side, half-way down)
a: flexes and pronates forearm, pronates hand

Flexor Carpi Radialis

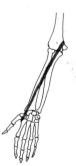

o: humerus (internal condyle to 1st metacarpal)
i: 2nd metacarpal (base of palm)
a: flexes wrist and bends up (medial rotation)

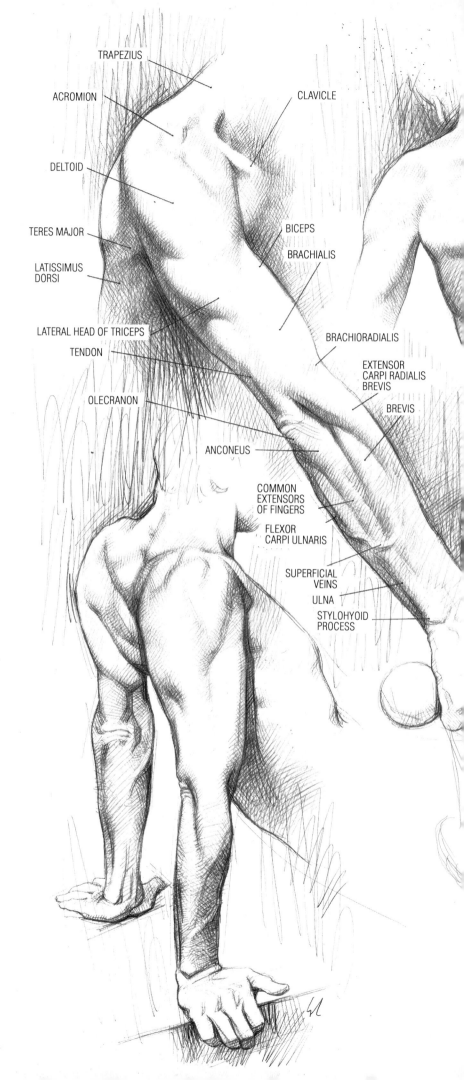

TRAPEZIUS

ACROMION

CLAVICLE

DELTOID

BICEPS

BRACHIALIS

TERES MAJOR

LATISSIMUS DORSI

BRACHIORADIALIS

EXTENSOR CARPI RADIALIS BREVIS

LATERAL HEAD OF TRICEPS

TENDON

BREVIS

OLECRANON

ANCONEUS

COMMON EXTENSORS OF FINGERS

FLEXOR CARPI ULNARIS

SUPERFICIAL VEINS

ULNA

STYLOHYOID PROCESS

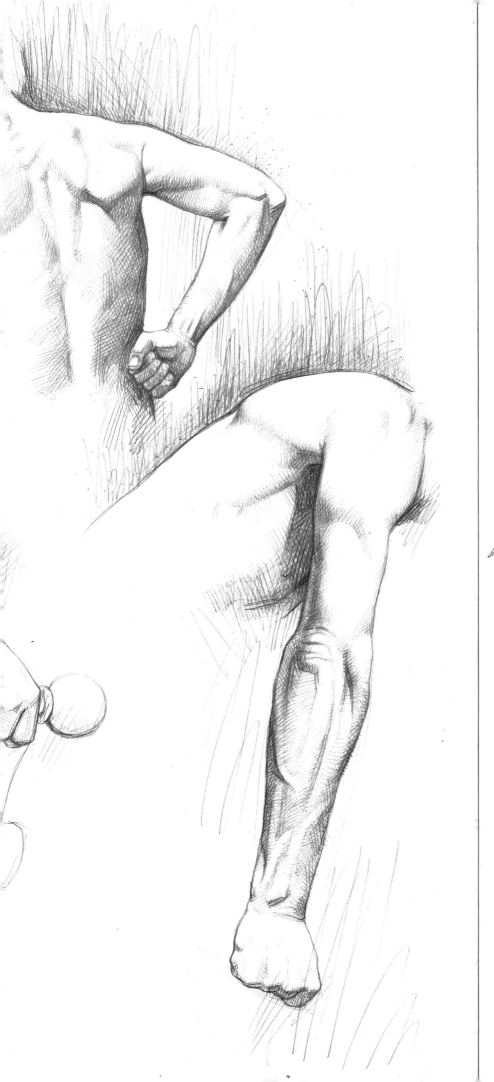

Palmaris Longus

o: humerus (internal condyle, fascia of forearm)
i: palmar aponeurosis
a: flexes hand

Flexor Carpi Ulnaris

o: humerus (internal condyle); ulna (olecranon, upper part of back)
i: pisiform (bone of carpus)
a: flexes wrist and hand, turns wrist outwards

Flexor Digitorum Sublimis

o: humerus (internal condyle); ulna (coronoid process); radius (upper half, front)
i: medial phalanges (palmar surface) of four fingers, from 1st to 4th
a: flexes fingers (but not thumb)

Brachioradialis

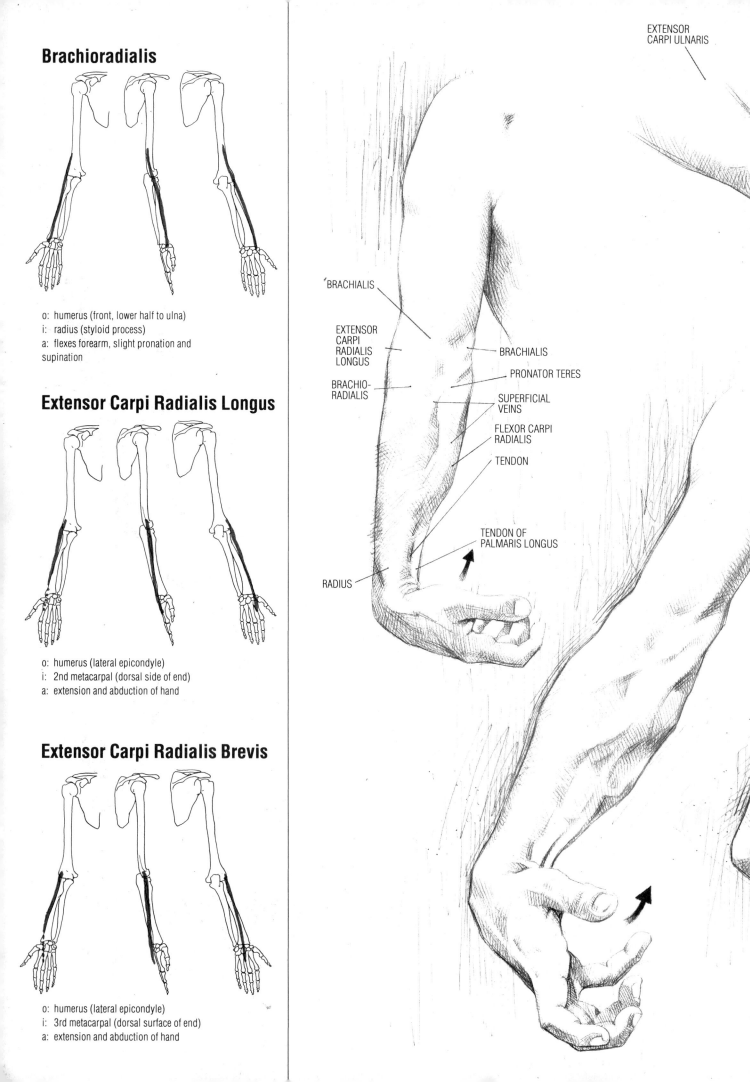

o: humerus (front, lower half to ulna)
i: radius (styloid process)
a: flexes forearm, slight pronation and
supination

Extensor Carpi Radialis Longus

o: humerus (lateral epicondyle)
i: 2nd metacarpal (dorsal side of end)
a: extension and abduction of hand

Extensor Carpi Radialis Brevis

o: humerus (lateral epicondyle)
i: 3rd metacarpal (dorsal surface of end)
a: extension and abduction of hand

EXTENSOR
CARPI ULNARIS

BRACHIALIS

EXTENSOR
CARPI
RADIALIS
LONGUS

BRACHIALIS

BRACHIO-
RADIALIS

PRONATOR TERES

SUPERFICIAL
VEINS

FLEXOR CARPI
RADIALIS

TENDON

TENDON OF
PALMARIS LONGUS

RADIUS

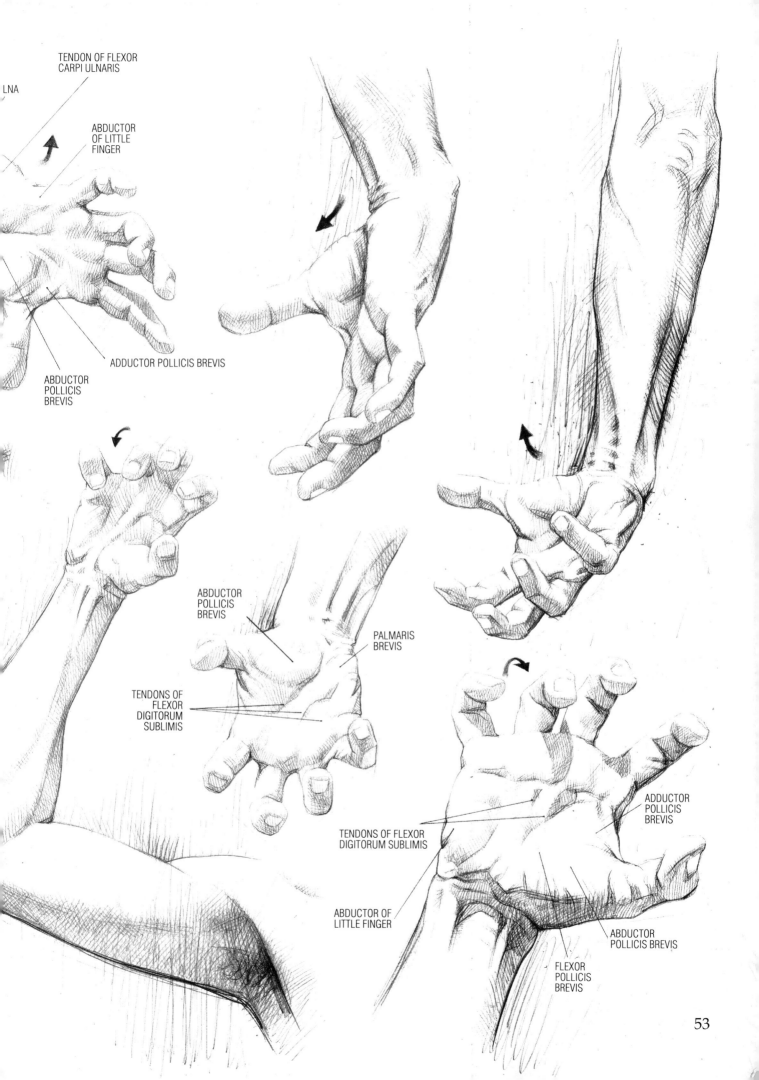

TENDON OF FLEXOR
CARPI ULNARIS

LNA

ABDUCTOR
OF LITTLE
FINGER

ADDUCTOR POLLICIS BREVIS

ABDUCTOR
POLLICIS
BREVIS

ABDUCTOR
POLLICIS
BREVIS

PALMARIS
BREVIS

TENDONS OF
FLEXOR
DIGITORUM
SUBLIMIS

TENDONS OF FLEXOR
DIGITORUM SUBLIMIS

ADDUCTOR
POLLICIS
BREVIS

ABDUCTOR OF
LITTLE FINGER

ABDUCTOR
POLLICIS BREVIS

FLEXOR
POLLICIS
BREVIS

53

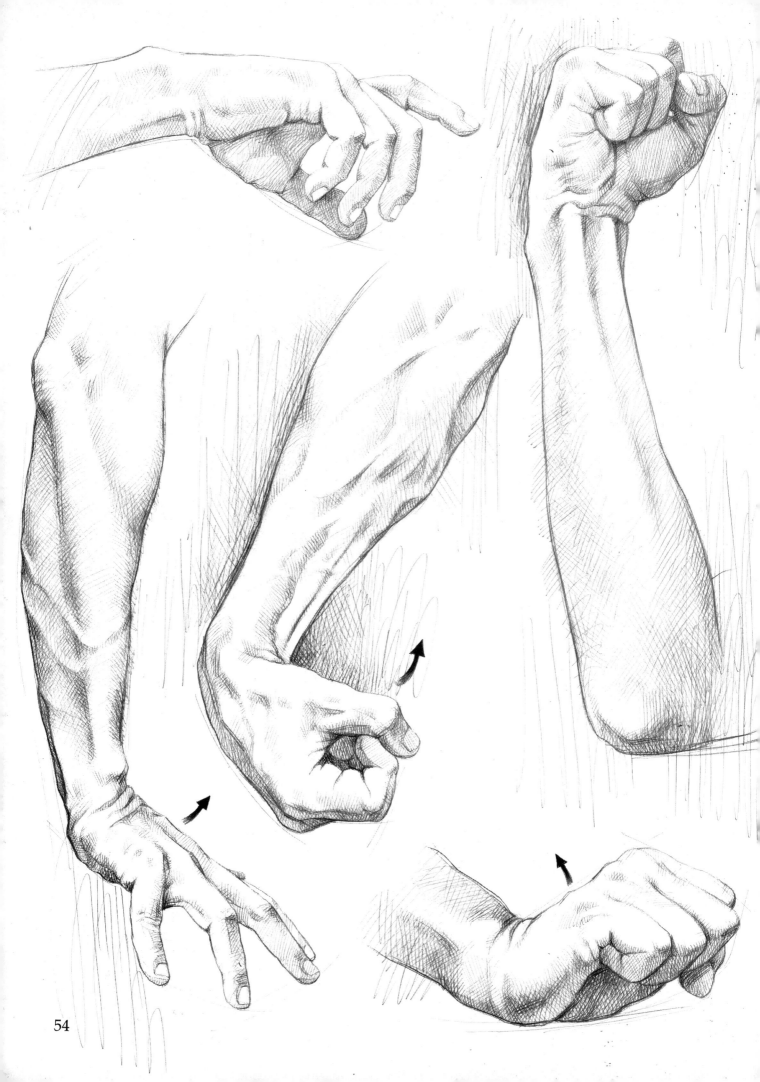

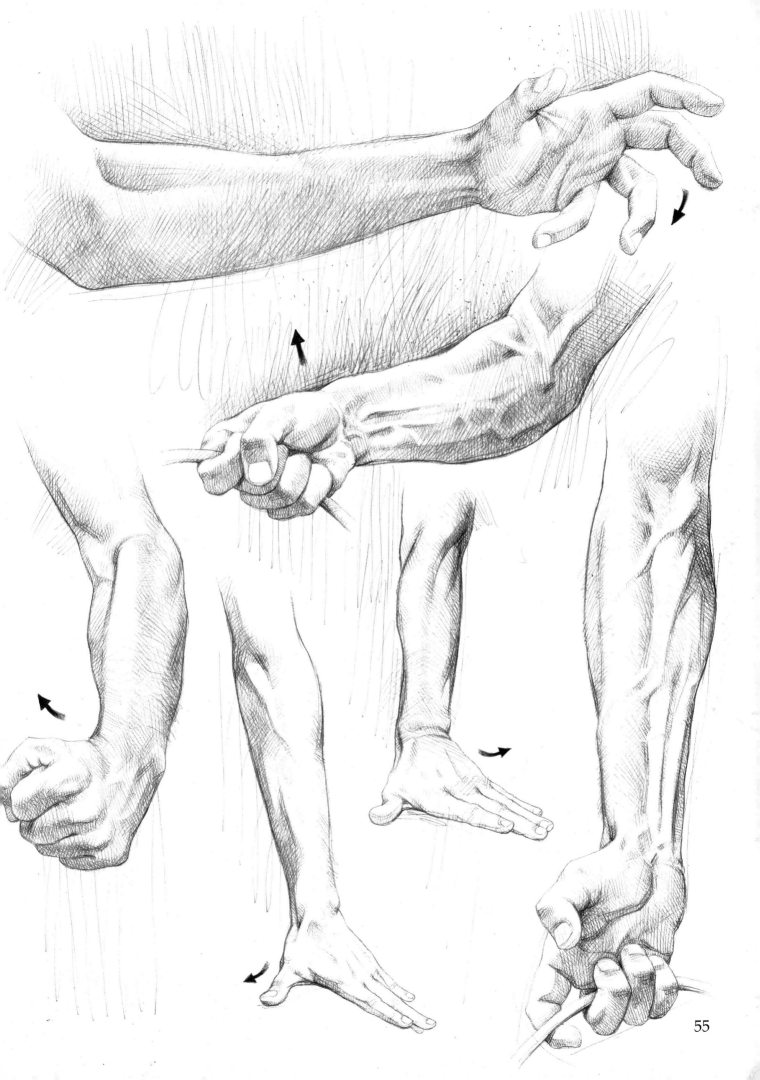

Flexor Digitorum Profundus

o: ulna (front), interosseous membrane
i: last phalanx (palmar surface) of the four fingers
a: flexes fingers (but not thumb)

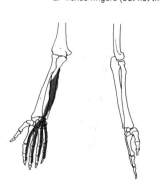

Flexor Pollicis Longus

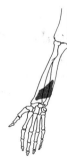

o: radius (middle tract, front), interosseous membrane
i: thumb (2nd phalanx, palmar surface)
a: flexes thumb

Pronator Teres

o: ulna (internal condyle to outer side of radius, half-way down)
i: radius (outer side)
a: pronates hand and flexes forearm

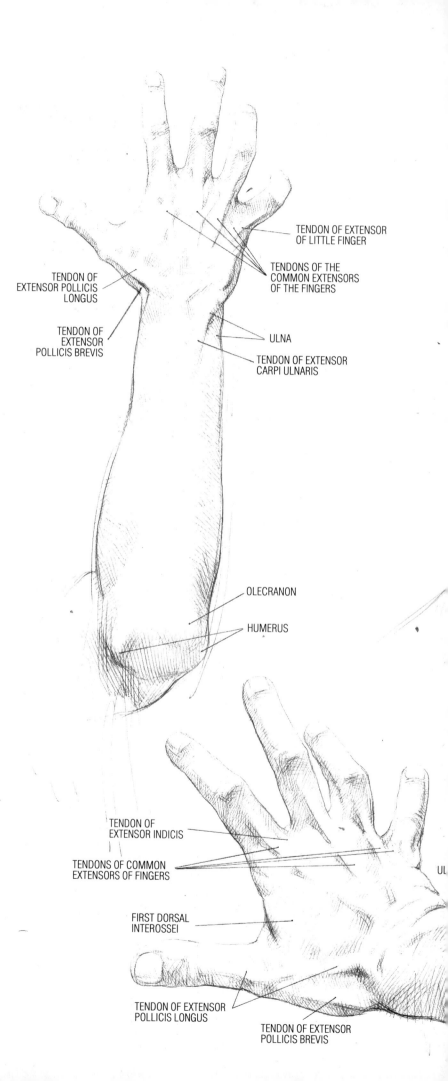

TENDON OF EXTENSOR OF LITTLE FINGER

TENDONS OF THE COMMON EXTENSORS OF THE FINGERS

TENDON OF EXTENSOR POLLICIS LONGUS

TENDON OF EXTENSOR POLLICIS BREVIS

ULNA

TENDON OF EXTENSOR CARPI ULNARIS

OLECRANON

HUMERUS

TENDON OF EXTENSOR INDICIS

TENDONS OF COMMON EXTENSORS OF FINGERS

FIRST DORSAL INTEROSSEI

UL

TENDON OF EXTENSOR POLLICIS LONGUS

TENDON OF EXTENSOR POLLICIS BREVIS

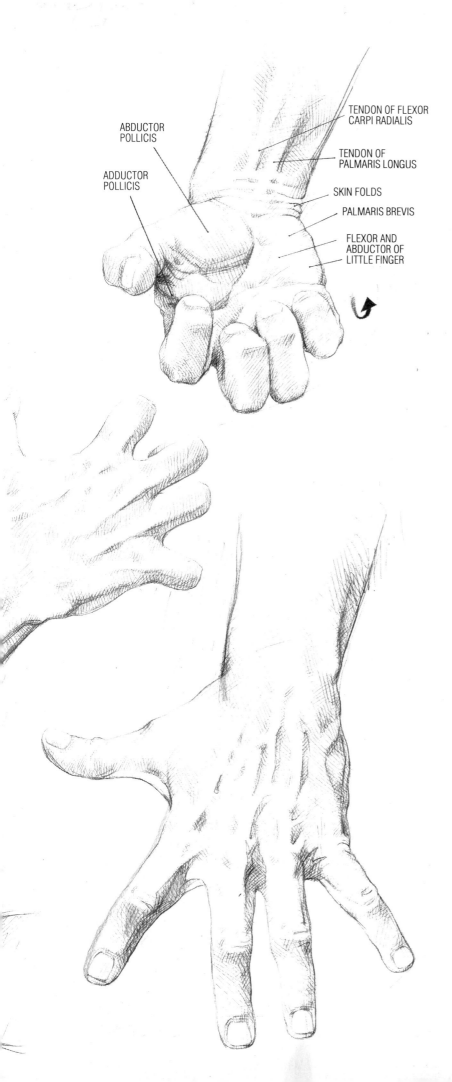

ABDUCTOR
POLLICIS

ADDUCTOR
POLLICIS

TENDON OF FLEXOR
CARPI RADIALIS

TENDON OF
PALMARIS LONGUS

SKIN FOLDS

PALMARIS BREVIS

FLEXOR AND
ABDUCTOR OF
LITTLE FINGER

Extensor Muscle of Little Finger

o: humerus (lateral epicondyle)
i: phalanges of the 4th finger
(dorsal surface)
a: extends little finger

Extensor Muscle of the Fingers

o: humerus (lateral epicondyle,
posterior face)
i: phalanges of the four fingers (dorsal
surface, tendinous sheath)
a: extends fingers (but not thumb)
and hand

Extensor Carpi Ulnaris

o: humerus (lateral epicondyle,
posterior face); ulna (posterior surface)
i: 5th metacarpal (dorsal surface at end)
a: extension and adduction of hand

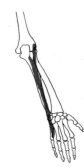

Supinator

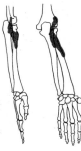

o: humerus (from external condyloid ridge to end of radius, ligaments of elbow); ulna (lateral surface)
i: radius (upper part, anterior and lateral surfaces)
a: supinates forearm

Abductor Pollicis Longus

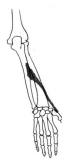

o: ulna (middle part, posterior surface); interosseous membrane; radius (posterior surface)
i: 1st metacarpal (lateral surface at base)
a: extension and abduction of thumb

Extensor Pollicis Brevis

o: radius (posterior surface, middle part); interosseus membrane
i: 1st phalanx of thumb (dorsal surface)
a: extension of 1st phalanx of thumb; abduction of hand

Extensor Pollicis Longus

o: ulna (middle part, posterior surface); interosseus membrane
i: 2nd phalanx of thumb (dorsal surface)
a: extension of the 2nd phalanx of thumb; abduction of thumb

Extensor Indicis

o: ulna (middle part, posterior surface); interosseous membrane
i: dorsal surface of 1st finger (tendinous sheath)
a: extension of index finger

58

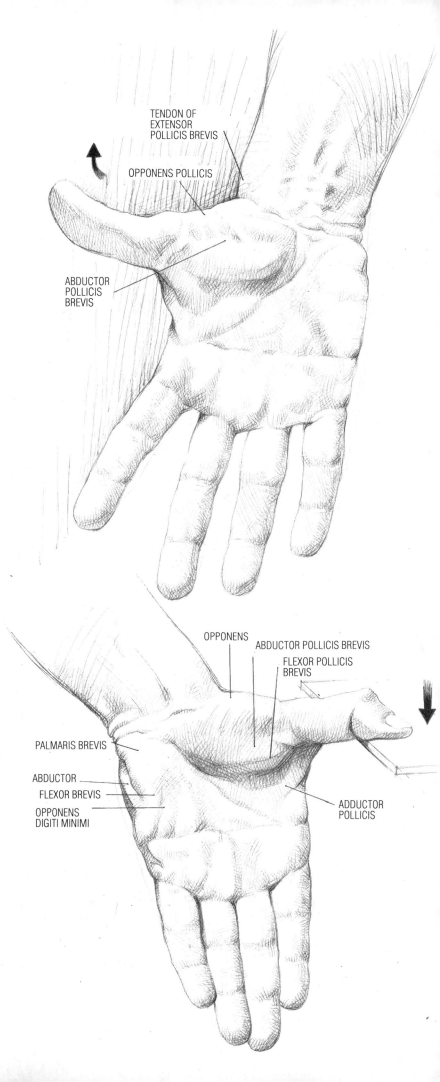

TENDON OF EXTENSOR POLLICIS BREVIS

OPPONENS POLLICIS

ABDUCTOR POLLICIS BREVIS

OPPONENS

ABDUCTOR POLLICIS BREVIS

FLEXOR POLLICIS BREVIS

PALMARIS BREVIS

ABDUCTOR

FLEXOR BREVIS

OPPONENS DIGITI MINIMI

ADDUCTOR POLLICIS

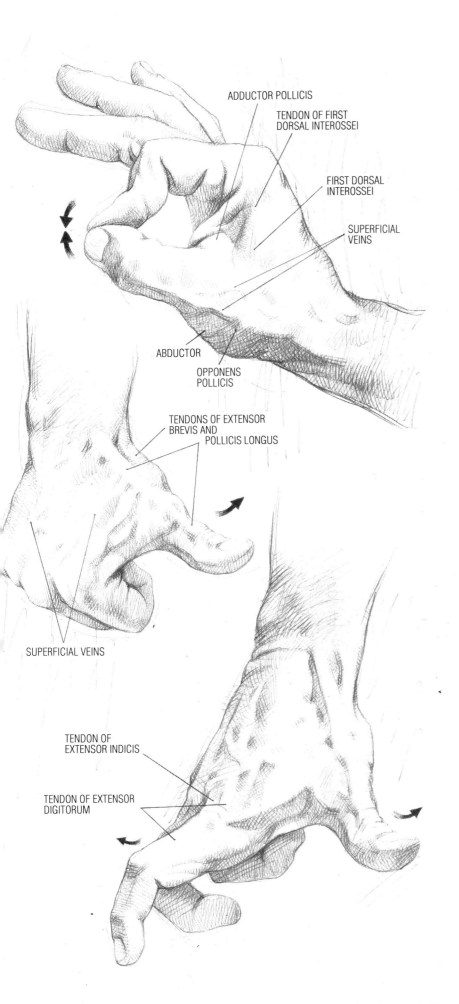

ADDUCTOR POLLICIS

TENDON OF FIRST
DORSAL INTEROSSEI

FIRST DORSAL
INTEROSSEI

SUPERFICIAL
VEINS

ABDUCTOR

OPPONENS
POLLICIS

TENDONS OF EXTENSOR
BREVIS AND
POLLICIS LONGUS

SUPERFICIAL VEINS

TENDON OF
EXTENSOR INDICIS

TENDON OF EXTENSOR
DIGITORUM

Abductor Pollicis Brevis

o: scaphoid (wrist bone); transverse ligament of wrist
i: 1st phalanx of thumb (lateral surface at base)
a: abduction of thumb; adduction of 1st metacarpal towards axis of hand

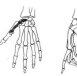

Flexor Pollicis Brevis

o: double-headed from palmar surface of wrist (transverse ligament, trapezium, capitate bone)
i: 1st phalanx of thumb (lateral surface of base)
a: flexes thumb; adduction and opposition of thumb

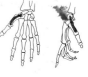

Opponens Pollicis

o: trapezium (palmar surface), transverse ligament of wrist
i: 1st metacarpal (lateral surface)
a: opposition to thumb from fingers

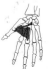

Adductor Pollicis

o: double-headed: capitate bone, hamate (palmar surface); 2nd and 3rd metacarpals (anterior surface)
i: 1st phalanx of thumb (medial surface of base)
a: adduction and opposition of thumb

Abductor Digiti Minimi

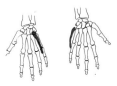

o: pisiform (anterior surface)
i: 1st phalanx of 4th (little)
finger (medial surface of base)
a: abduction (moving away of
little finger from axis of the
hand)

Flexor Ditigi Minimi Brevis

o: hamate bone (anterior surface);
transverse ligament
i: 1st phalanx of 4th (little) finger
(medial surface)
a: flexion and abduction of little finger

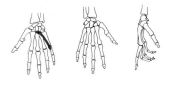

Opponens Digiti Minimi

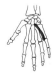

o: hamate bone (anterior surface);
transverse ligament
i: 5th metacarpal (medial side)
a: opposition of little finger to thumb

Lumbrical

Four muscles found between the tendons of the deep flexor
muscles of the fingers (palmar surface of the metacarpals)
covered by palmar aponeurosis.

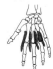

a: flexion of the 1st phalanx of the four
fingers, extension of the 2nd and 3rd
phalanges

Interossei

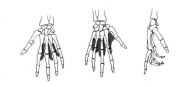

o: palmar: palmar surface from 1st, 2nd, 4th, 5th
metacarpals; dorsal: dorsal surface of all metacarpals
i: first phalanges of corresponding finger, tendons of flexors
and extensors
a: flexors of 1st phalanx: adduction, spreading of fingers

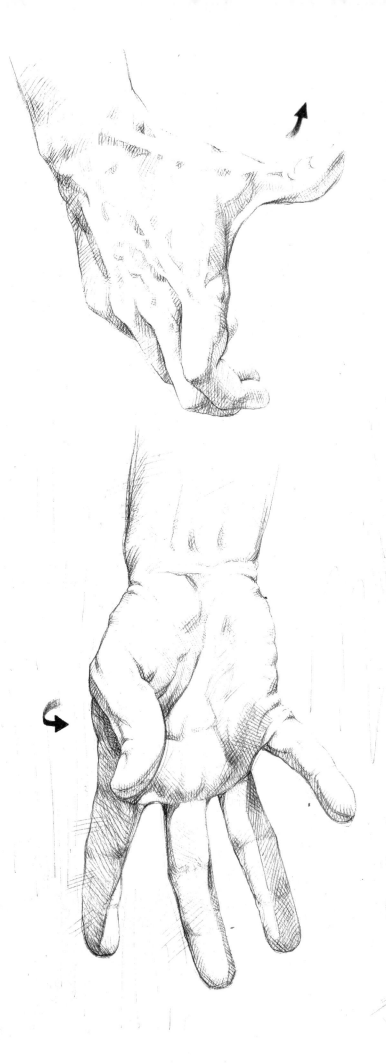

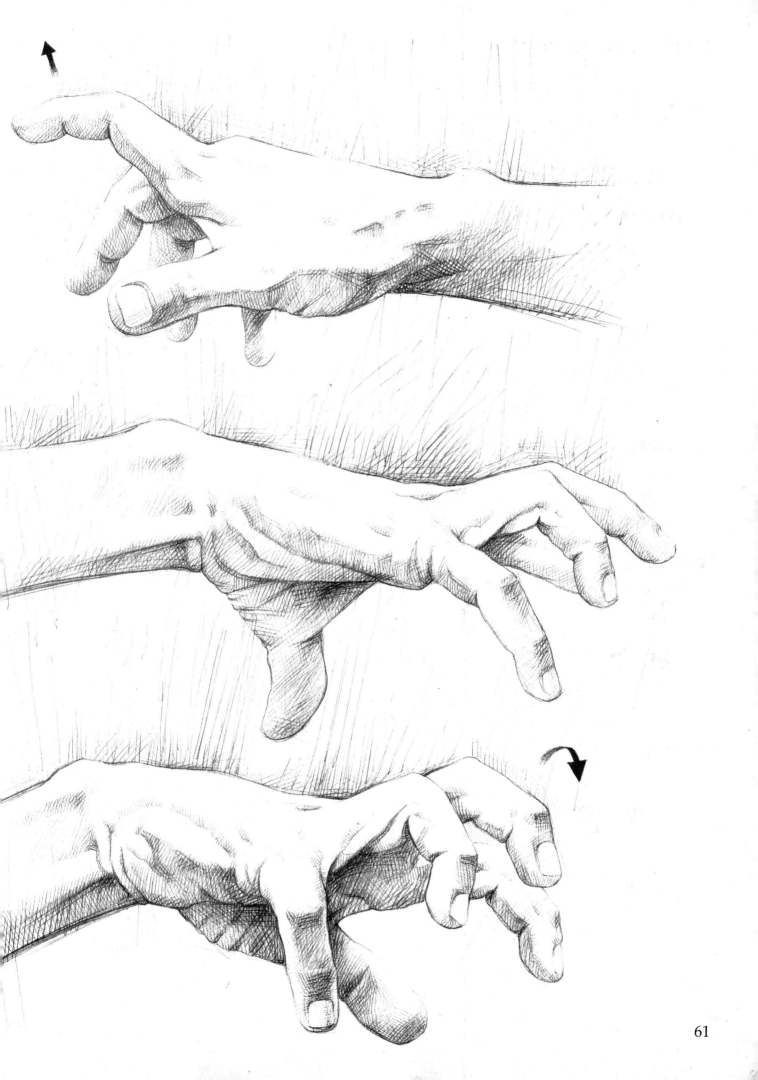

LOWER LIMB MUSCLES

The lower limb is divided into three free parts: the thigh, the leg and the foot, articulated at the level of the hip with the pelvis (formed by the fusion of the ilium, the ischium and the pubis). The functional plane is similar to that of the upper limb.

The thigh is conical, with the larger end at the haunch and the smaller one at the knee; the muscles surrounding the femur are divided into three groups: anterior (extensor), posterior (flexor), medial (adductor). At the level of articulation of the knee is found, anteriorly, the knee-cap (patella). The leg is rounded, with the narrower part nearer the foot. The muscles round the tibia (medially positioned) and the peroneus (laterally) are divided into the anterolateral group (mainly the extensors of the foot) and posterior group (flexors).

The foot is arched (with a transverse flattening) due to the bone structure (tarsus, metatarsus, phalanges). The muscles (plantar and dorsal) are hardly visible: on the dorsal plane of the foot the tendons of the extensor muscles run down.

Some of the covering bands of sheathing of the muscles and the mechanics of the large articulations of the limb are important in external morphology, both in the upright position and in dynamic poses.

Psoas Minor

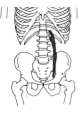

o: 12th thoracic and 1st lumbar vertebrae (lateral surface of the vertebral body)
i: ilium (iliac–pectineal crest), pubis (body of)
a: tendons of the fascia lata, weak flexion of the pelvis on the lumbar vertebrae

Psoas Major and Iliacus

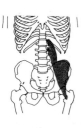

o: vertebrae from the 12th thoracic to the 4th lumbar (vertebral body and transverse costiform process), ilium (inner surface)
i: femur (lesser trochanter)
a: flexion of the thigh on the pelvis (and vice versa); outer rotation of the femur (with adduction and slight flexion); lateral flexion of the spine

Gluteus Minimus

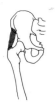
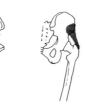

o: ilium (outer fascia)
i: femur (apex of the greater trochanter)
a: abduction; lateral and medial rotation of the thigh; sideways bending and flexion of the pelvis

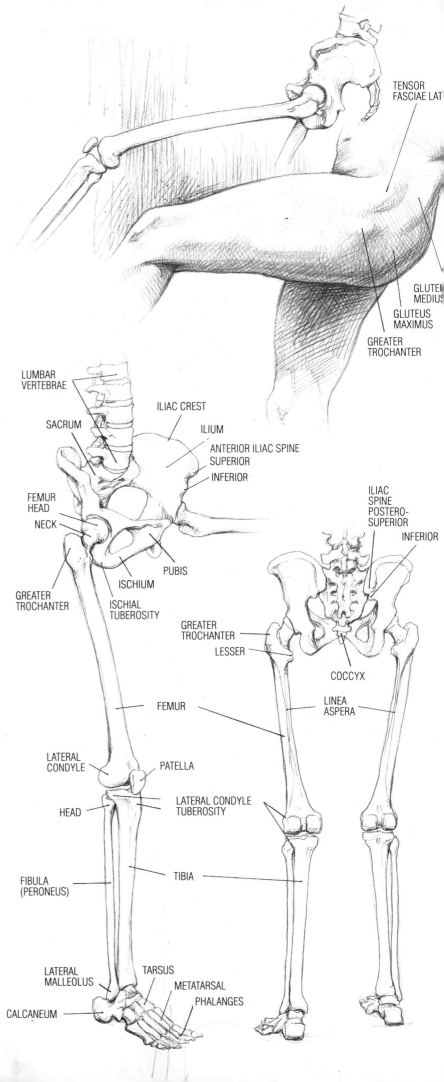

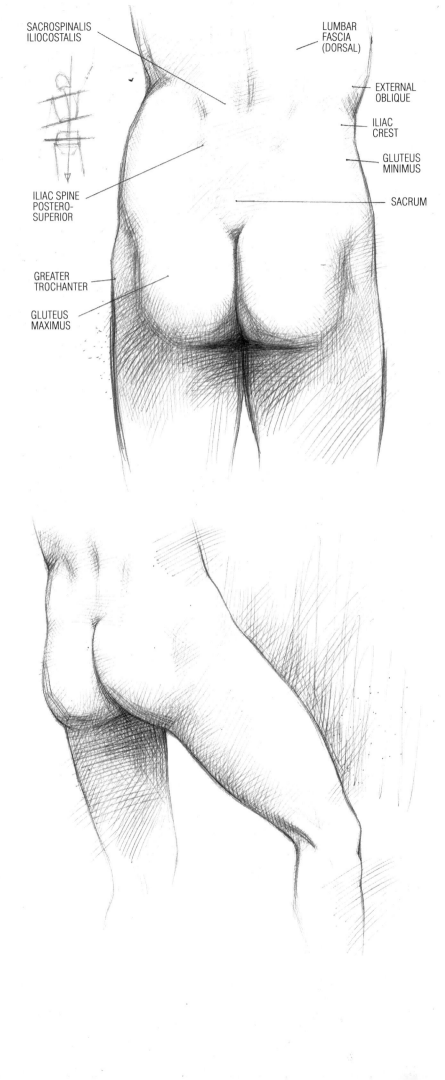

SACROSPINALIS
ILIOCOSTALIS

LUMBAR
FASCIA
(DORSAL)

EXTERNAL
OBLIQUE

ILIAC
CREST

GLUTEUS
MINIMUS

ILIAC SPINE
POSTERO-
SUPERIOR

SACRUM

GREATER
TROCHANTER

GLUTEUS
MAXIMUS

Gluteus Maximus

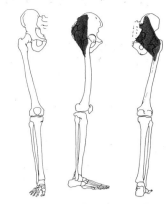

o: ilium (rear portion of wing and posterior iliac crest)

i: femur (greater trochanter and gluteal tuberosity), fascia lata (iliotibial tract)

a: extension of thigh; adduction and lateral rotation of thigh; extension of pelvis. This muscle is important in walking and in standing upright

Gluteus Medius

o: ilium (external fascia)

i: femur (lateral fascia of the greater trochanter)

a: abduction; lateral and medial rotation of the inward thigh

Tensor Fasciae Latae

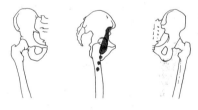

o: ilium (anterosuperior iliac spine, external margins of the iliac crest)

i: fascia lata, iliotibial tract

a: tendons of the fascia lata (standing upright); flexion and adduction of the thigh; extension of the leg

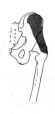

63

Piriformis

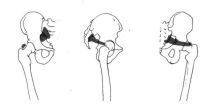

o: (bone of) sacrum (anterior surface, from 2nd and 4th foramina)
i: femur (apex of greater trochanter)
a: abduction and outward rotation of thigh

Obturator Internus

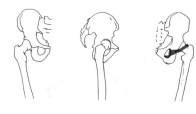

o: pubis (ramus, obturator foramen)
i: femur (trochanteric fossa)
a: slight outward rotation of thigh

Gemellus Superior and Inferior

o: ischial spine and tuberosity
i: femur (posterior surface of neck)
a: weak outward rotation of femur

Quadratus Femoris

o: ischium (lateral margin of the tuberosity)
i: femur (intertrochanteric crest)
a: weak adduction and outward rotation of thigh

Sartorius

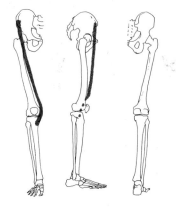

o: ilium (anterosuperior spine)
i: tibia (medial margin of the tuberosity)
a: flexion of leg and thigh; medial rotation of flexed leg

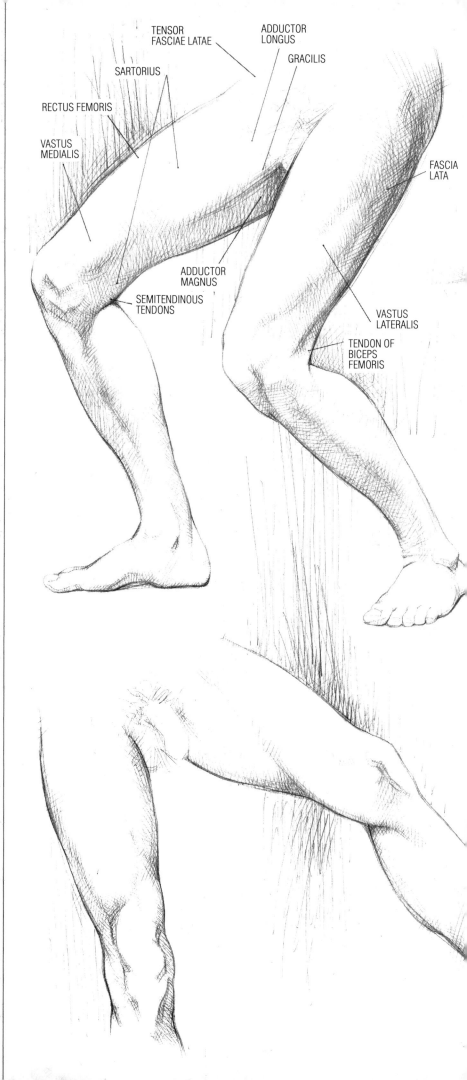

TENSOR FASCIAE LATAE
ADDUCTOR LONGUS
GRACILIS
SARTORIUS
RECTUS FEMORIS
VASTUS MEDIALIS
FASCIA LATA
ADDUCTOR MAGNUS
SEMITENDINOUS TENDONS
VASTUS LATERALIS
TENDON OF BICEPS FEMORIS

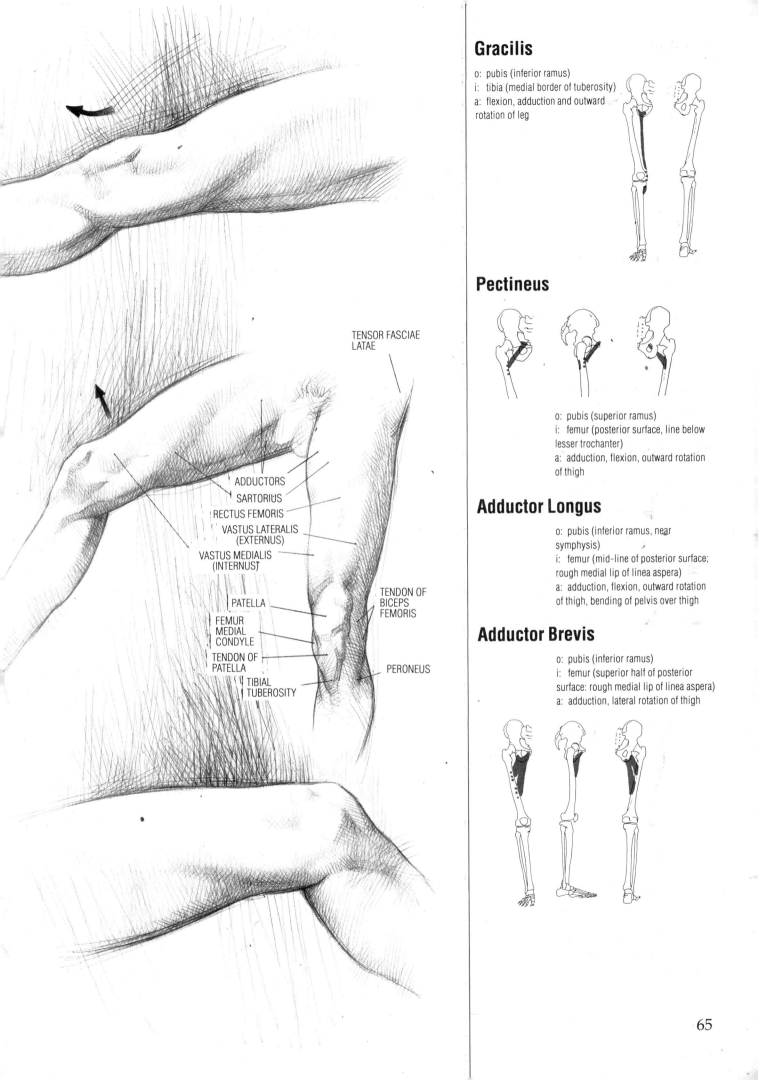

TENSOR FASCIAE
LATAE

ADDUCTORS

SARTORIUS

RECTUS FEMORIS

VASTUS LATERALIS
(EXTERNUS)

VASTUS MEDIALIS
(INTERNUS)

TENDON OF
BICEPS
FEMORIS

PATELLA

FEMUR
MEDIAL
CONDYLE

TENDON OF
PATELLA

PERONEUS

TIBIAL
TUBEROSITY

Gracilis

o: pubis (inferior ramus)
i: tibia (medial border of tuberosity)
a: flexion, adduction and outward
rotation of leg

Pectineus

o: pubis (superior ramus)
i: femur (posterior surface, line below
lesser trochanter)
a: adduction, flexion, outward rotation
of thigh

Adductor Longus

o: pubis (inferior ramus, near
symphysis)
i: femur (mid-line of posterior surface;
rough medial lip of linea aspera)
a: adduction, flexion, outward rotation
of thigh, bending of pelvis over thigh

Adductor Brevis

o: pubis (inferior ramus)
i: femur (superior half of posterior
surface: rough medial lip of linea aspera)
a: adduction, lateral rotation of thigh

65

Quadriceps Femoris

This is formed by four heads meeting in one tendon of insertion.

RECTUS FEMORIS o: ilium (anteroinferior spine)

VASTUS LATERALIS o: femur (posterior surface: lateral lips of linea aspera)

VASTUS MEDIALIS o: femur (posterior surface: medial lips of linea aspera)

VASTUS INTERMEDIUS o: femur (anterior surface)
i: (joining of four heads): patella and tibia (tuberosity)
a: total: extension of leg on to thigh and vice versa; flexion of thigh (rectus femoris); mechanism of upright stance

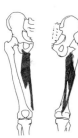

Adductor Magnus

o: ischium (inferior ramus and tuberosity)
i: femur (posterior surface: medial lip of linea aspera) (medial epicondyle)
a: adduction, flexion, extension and lateral rotation of thigh

Biceps Femoris

o: long head: ischium (tuberosity); short head: femur (posterior surface: mid-tract of lateral lips of linea aspera)
i: fibula (head)
a: flexion of leg; extension of thigh; outward rotation of the flexed limb

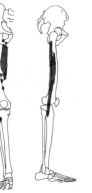
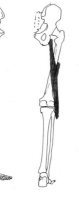

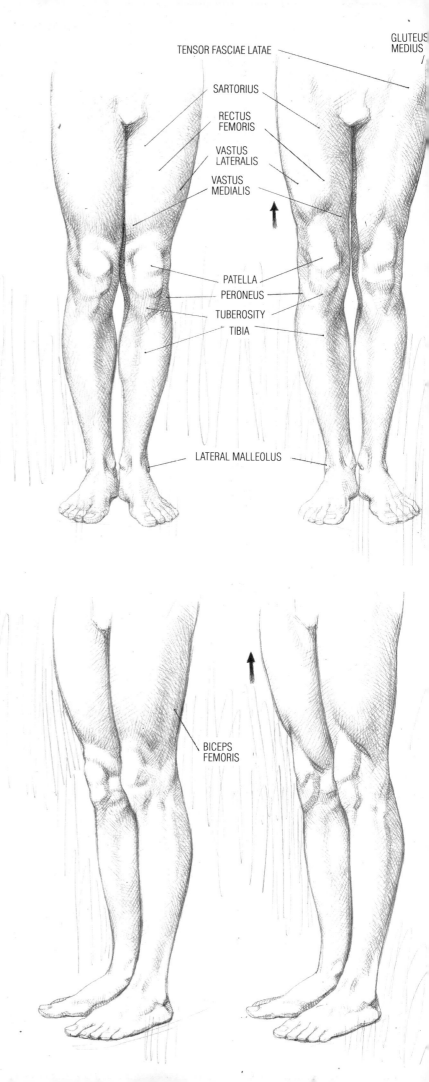

TENSOR FASCIAE LATAE

GLUTEUS MEDIUS

SARTORIUS

RECTUS FEMORIS

VASTUS LATERALIS

VASTUS MEDIALIS

PATELLA

PERONEUS

TUBEROSITY

TIBIA

LATERAL MALLEOLUS

BICEPS FEMORIS

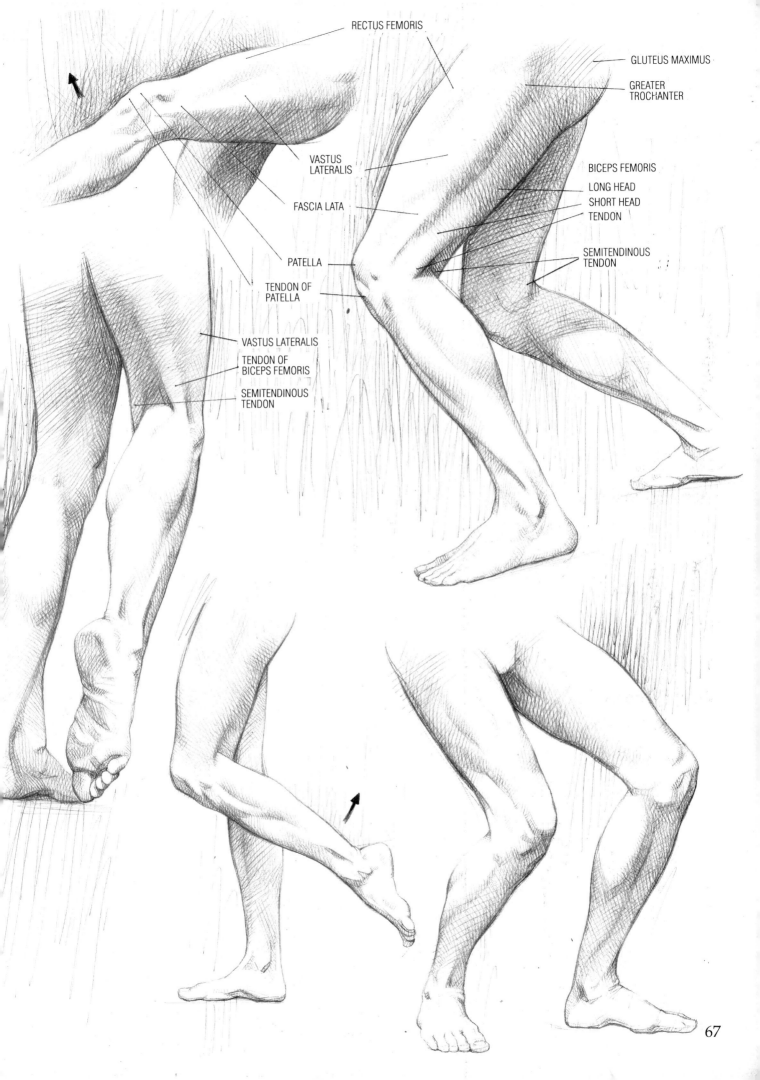

RECTUS FEMORIS

GLUTEUS MAXIMUS

GREATER TROCHANTER

VASTUS LATERALIS

BICEPS FEMORIS

LONG HEAD

FASCIA LATA

SHORT HEAD TENDON

SEMITENDINOUS TENDON

PATELLA

TENDON OF PATELLA

VASTUS LATERALIS

TENDON OF BICEPS FEMORIS

SEMITENDINOUS TENDON

67

Obturator Externus

o: pubis (superior and inferior ramus)
i: femur (trochanteric fossa)
a: outward rotation of femur

Semitendinosus

o: ischium (tuberosity)
i: tibia (medial edge of tuberosity)
a: flexion of leg (with inner rotation), extension of thigh

Semimembranosus

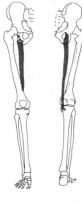

o: ischium (tuberosity)
i: tibia (posterior side of medial condyle)
a: flexion of leg; extension of thigh

Tibialis Anterior

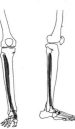

o: tibia (lateral condyle and superior tract of lateral side)
i: 1st metatarsal (plantar side of base), first cuneiform
a: dorsal flexion of foot with inner rotation; slight adduction of foot

Extensor Digitorum Longus

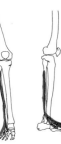

o: tibia (lateral condyle), fibula (anterior margin), interosseous membrane
i: with four tendons to the dorsal side of the four toes (except the great toe)
a: extension of toes; dorsal flexion of foot

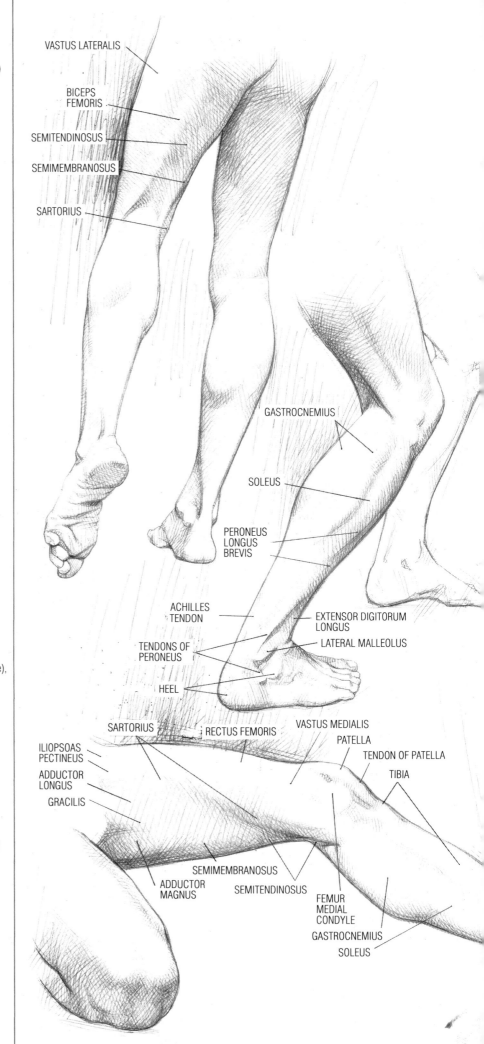

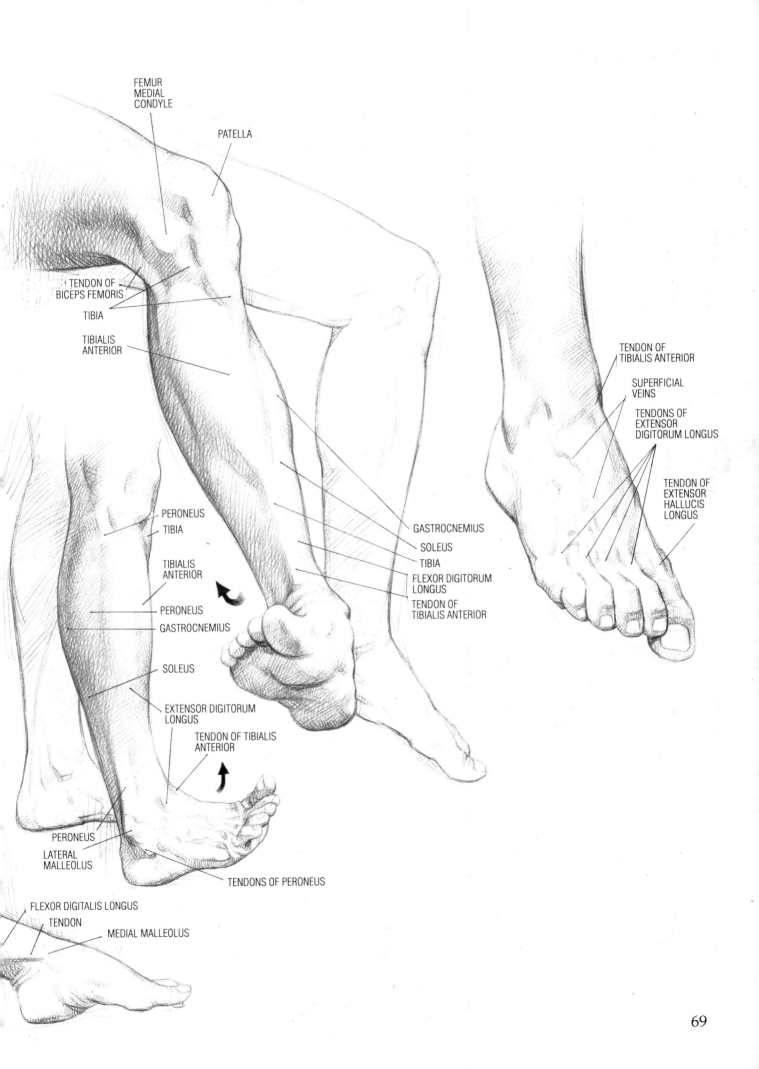

FEMUR
MEDIAL
CONDYLE

PATELLA

TENDON OF
BICEPS FEMORIS

TIBIA

TIBIALIS
ANTERIOR

TENDON OF
TIBIALIS ANTERIOR

SUPERFICIAL
VEINS

TENDONS OF
EXTENSOR
DIGITORUM LONGUS

TENDON OF
EXTENSOR
HALLUCIS
LONGUS

PERONEUS

TIBIA

TIBIALIS
ANTERIOR

PERONEUS

GASTROCNEMIUS

GASTROCNEMIUS

SOLEUS

TIBIA

FLEXOR DIGITORUM
LONGUS

TENDON OF
TIBIALIS ANTERIOR

SOLEUS

EXTENSOR DIGITORUM
LONGUS

TENDON OF TIBIALIS
ANTERIOR

PERONEUS

LATERAL
MALLEOLUS

TENDONS OF PERONEUS

FLEXOR DIGITALIS LONGUS

TENDON

MEDIAL MALLEOLUS

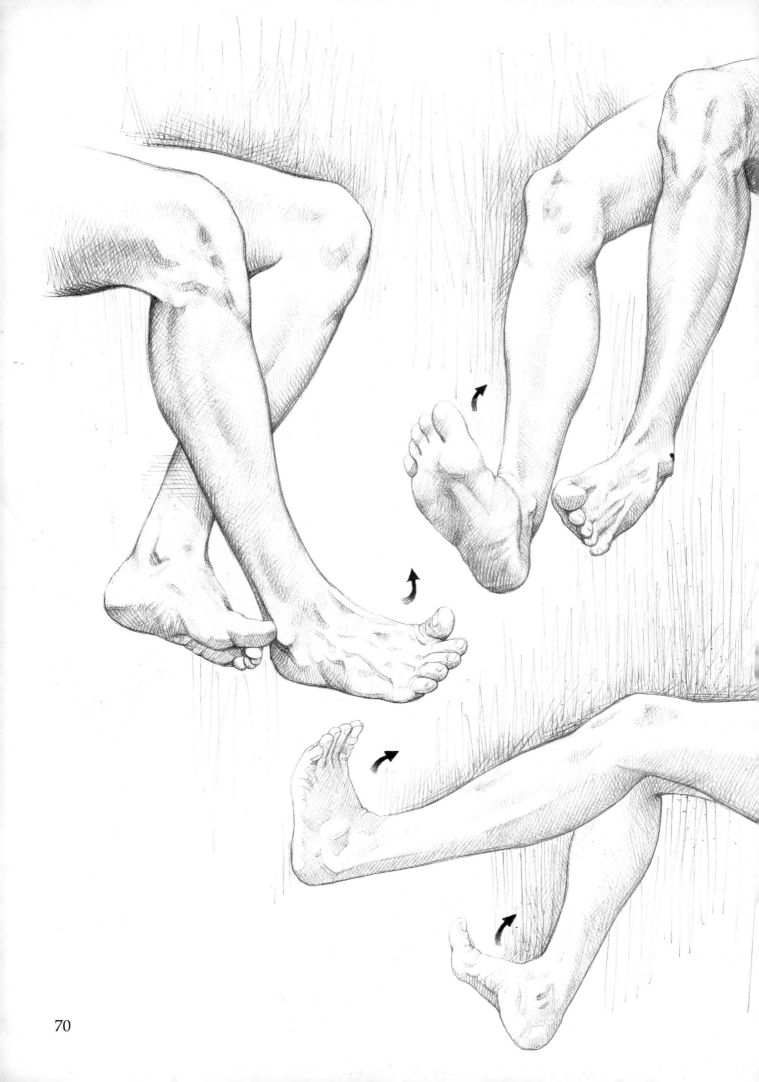

70

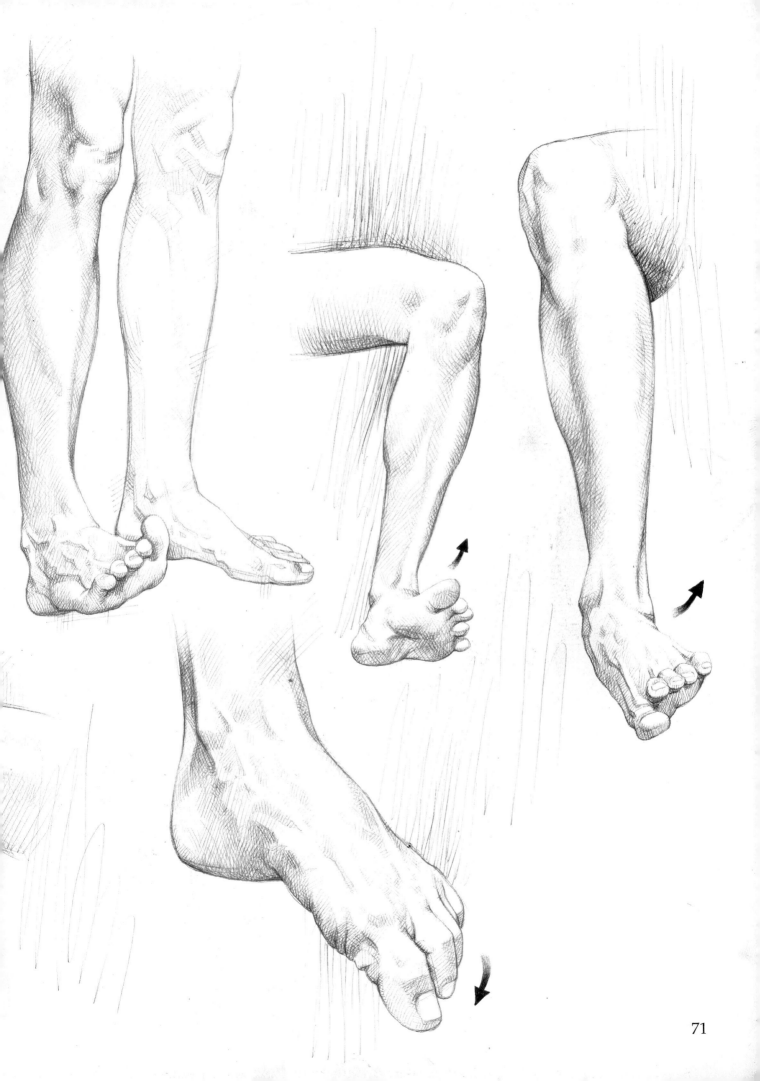

Peroneus Anterior

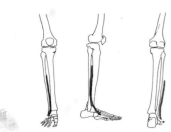

This is named after peroneus tertius.

o: fibula (inferior tract of medial side)
i: 5th metatarsal (dorsal surface of the base)
a: dorsal flexion; abduction and lateral rotation of foot

Flexor Hallucis Longus

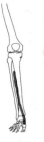

o: fibula (middle tract of the medial side), interosseous membrane
i: 1st and 2nd phalanges of great toe, dorsal surface
a: extension, dorsal flexion of great toe

Peroneus

Subdivided into peroneus longus and peroneus brevis:

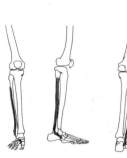

LONGUS
o: fibula (head and upper half of the lateral side)
i: 1st metatarsal (plantar side of base and tuberosity: the tendons run down behind to inferior end of fibula and diagonally across sole of foot)

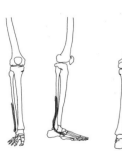

BREVIS
o: fibula (middle tract of the lateral side)
i: 5th metatarsal (lateral side of base)
a: general: plantar flexion of foot (with raising of lateral edges)

Plantaris

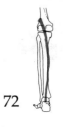

o: femur (lateral epicondyle)
i: medial margins of Achilles tendon
a: plantar flexion of foot; flexion of leg

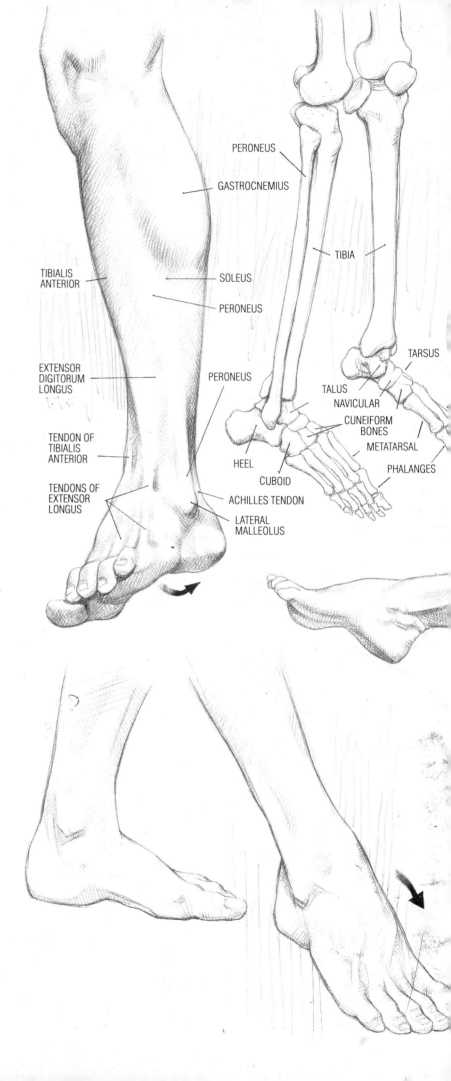

PERONEUS
GASTROCNEMIUS
TIBIA
TIBIALIS ANTERIOR
SOLEUS
PERONEUS
TARSUS
EXTENSOR DIGITORUM LONGUS
PERONEUS
TALUS
NAVICULAR
CUNEIFORM BONES
METATARSAL
TENDON OF TIBIALIS ANTERIOR
HEEL
CUBOID
PHALANGES
TENDONS OF EXTENSOR LONGUS
ACHILLES TENDON
LATERAL MALLEOLUS

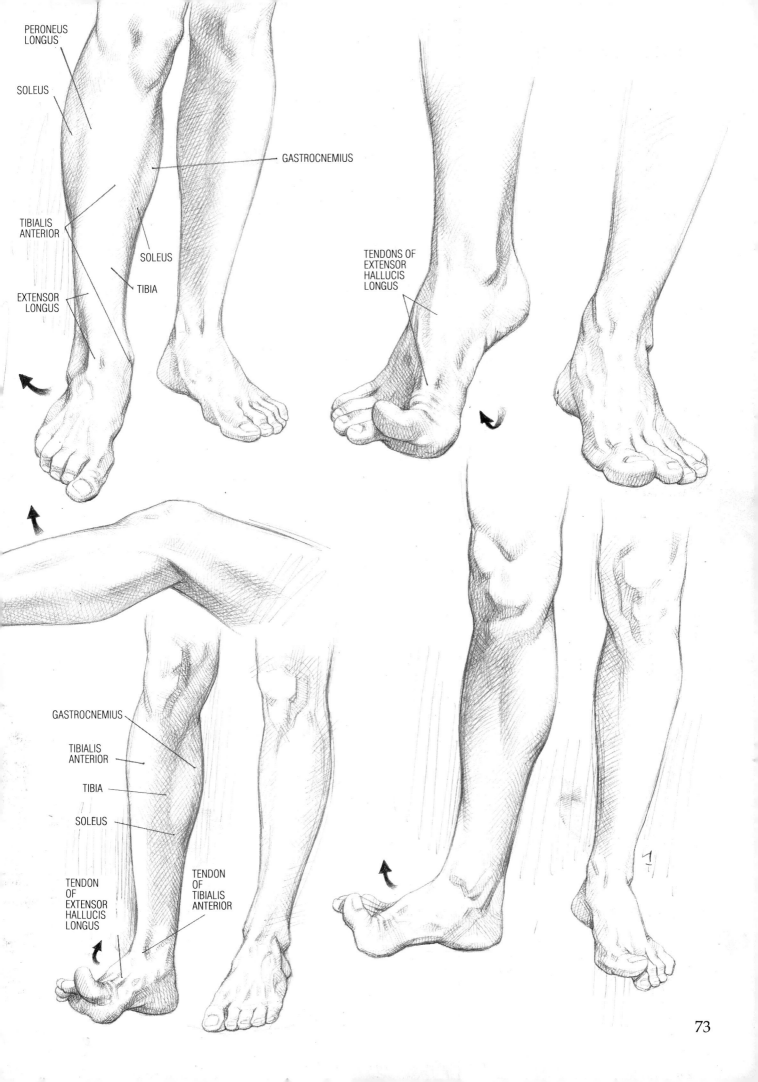

PERONEUS
LONGUS

SOLEUS

GASTROCNEMIUS

TIBIALIS
ANTERIOR

SOLEUS

EXTENSOR
LONGUS

TIBIA

TENDONS OF
EXTENSOR
HALLUCIS
LONGUS

GASTROCNEMIUS

TIBIALIS
ANTERIOR

TIBIA

SOLEUS

TENDON
OF
EXTENSOR
HALLUCIS
LONGUS

TENDON
OF
TIBIALIS
ANTERIOR

Gastrocnemius

The superficial part of the triceps of the calf.

o: middle or long head: femur (medial epicondyle); short head: femur (lateral epicondyle)
i: heel (tuberosity, Achilles tendon)
a: plantar flexion of foot; flexion of leg; abduction of foot (the complex action is very important in walking and standing upright)

Soleus

This is the deepest part of the triceps muscle of the calf; the superficial part is the gastrocnemius.
o: tibia (superior tract of posterior side), fibula (head and superior tract of posterior side)
i: heel (tuberosity, posterior side, for the passage of the common tendons of the triceps; Achilles heel)
a: extension (plantar flexion) of foot

Popliteus

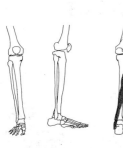

o: femur (lateral condyle)
i: tibia (superior tract of posterior side)
a: flexion of leg (with medial rotation)

Flexor Digitorum Longus

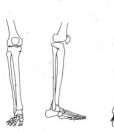

o: tibia (middle tract of posterior side)
i: last phalanx of the four toes (excluding the great toe)
a: flexion of toes and sole of foot; adduction of foot

Flexor Hallucis Longus

o: fibula (middle tract of posterior side)
i: last phalanx of the great toe, plantar side
a: flexion of great toe and sole of foot; adduction of foot

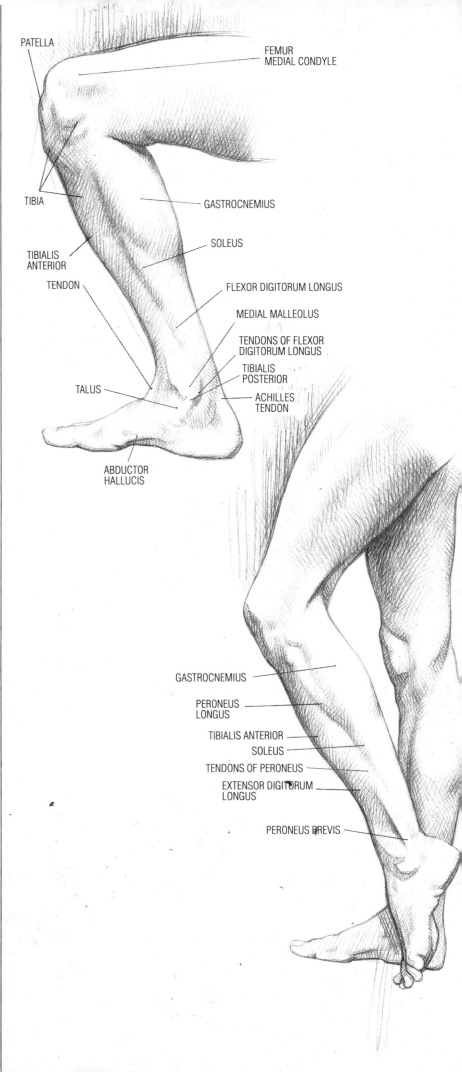

PATELLA

FEMUR
MEDIAL CONDYLE

TIBIA

TIBIALIS
ANTERIOR

TENDON

TALUS

ABDUCTOR
HALLUCIS

GASTROCNEMIUS

SOLEUS

FLEXOR DIGITORUM LONGUS

MEDIAL MALLEOLUS

TENDONS OF FLEXOR
DIGITORUM LONGUS

TIBIALIS
POSTERIOR

ACHILLES
TENDON

GASTROCNEMIUS

PERONEUS
LONGUS

TIBIALIS ANTERIOR

SOLEUS

TENDONS OF PERONEUS

EXTENSOR DIGITORUM
LONGUS

PERONEUS BREVIS

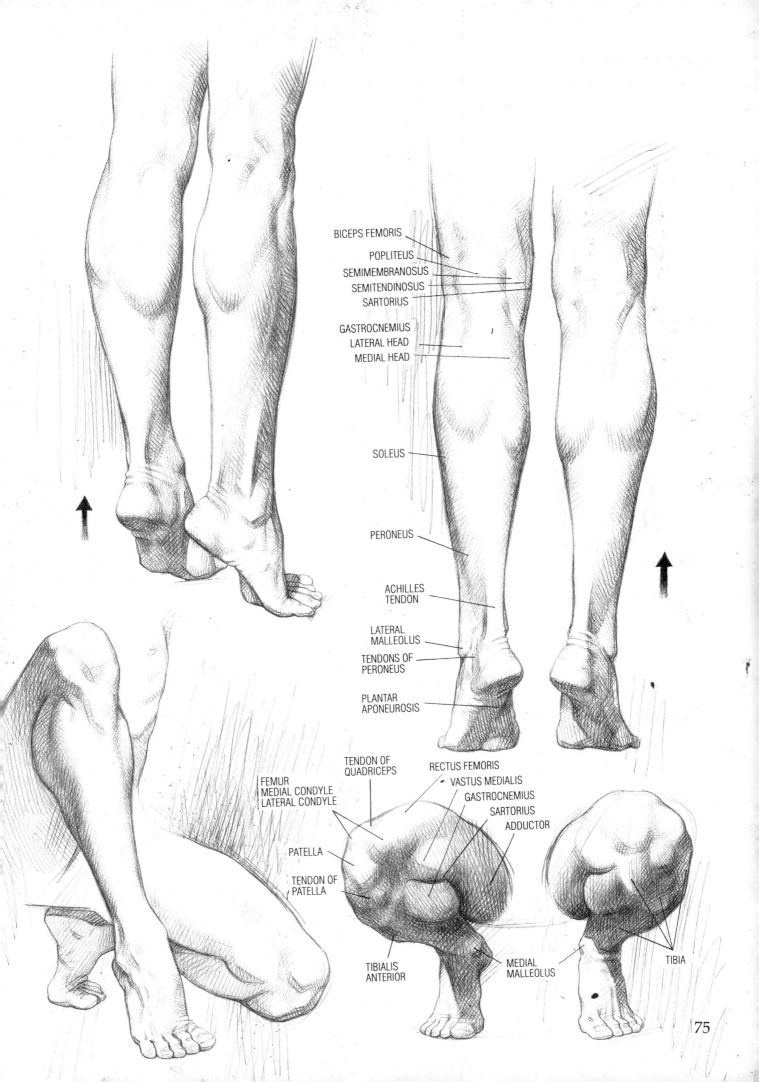

BICEPS FEMORIS

POPLITEUS

SEMIMEMBRANOSUS

SEMITENDINOSUS

SARTORIUS

GASTROCNEMIUS
LATERAL HEAD
MEDIAL HEAD

SOLEUS

PERONEUS

ACHILLES
TENDON

LATERAL
MALLEOLUS

TENDONS OF
PERONEUS

PLANTAR
APONEUROSIS

TENDON OF
QUADRICEPS

RECTUS FEMORIS

VASTUS MEDIALIS

GASTROCNEMIUS

SARTORIUS

ADDUCTOR

FEMUR
MEDIAL CONDYLE
LATERAL CONDYLE

PATELLA

TENDON OF
PATELLA

TIBIALIS
ANTERIOR

MEDIAL
MALLEOLUS

TIBIA

Tibialis

o: tibia (shin) (middle tract of posterior side), interosseous membrane
i: navicular bone, cuneiform bones, plantar surface of 2nd to 4th metatarsals
a: flexes sole of foot, with adduction and medial rotation

Extensor Digitorum Brevis

This is the short extensor muscle of the great toe.
o: heel (dorsal and lateral sides)
i: 1st phalanx of the great toe and the three middle toes (dorsal side of base)
a: extension (dorsal flexion) of toes, with slight sideways movement

Flexor Hallucis Brevis

o: cuneiform bones (plantar surface)
i: 1st phalanx of great toe (plantar side of base)
a: flexion of great toe

Adductor Hallucis

o: oblique head: 2nd, 3rd, 4th metatarsals (plantar side of base), cuboid bone, cuneiform bones; transverse head: articular capsule (plantar surface) of the articulation of 3rd, 4th, 5th metatarsophalanges
i: 1st phalanx of great toe (lateral face)
a: adduction towards medial axis of great toe

Abductor Hallucis

o: heel (medial face of tuberosity)
i: 1st phalanx of great toe (medial face of base)
a: flexion and abduction of great toe (that is, raising of great toe towards the medial plane of symmetry and, thus, lengthening of the longitudinal axis of foot)

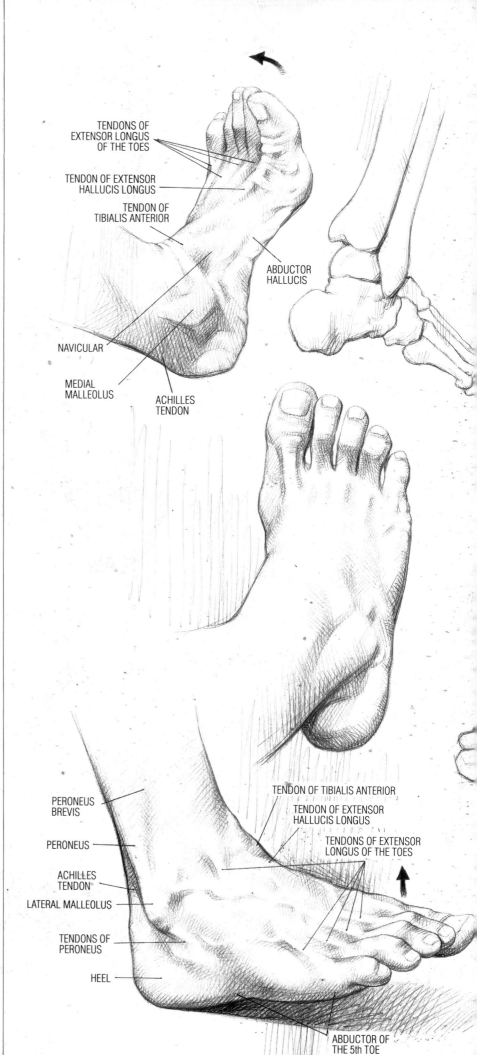

TENDONS OF EXTENSOR LONGUS OF THE TOES
TENDON OF EXTENSOR HALLUCIS LONGUS
TENDON OF TIBIALIS ANTERIOR
ABDUCTOR HALLUCIS
NAVICULAR
MEDIAL MALLEOLUS
ACHILLES TENDON

TENDON OF TIBIALIS ANTERIOR
TENDON OF EXTENSOR HALLUCIS LONGUS
TENDONS OF EXTENSOR LONGUS OF THE TOES
PERONEUS BREVIS
PERONEUS
ACHILLES TENDON
LATERAL MALLEOLUS
TENDONS OF PERONEUS
HEEL
ABDUCTOR OF THE 5th TOE

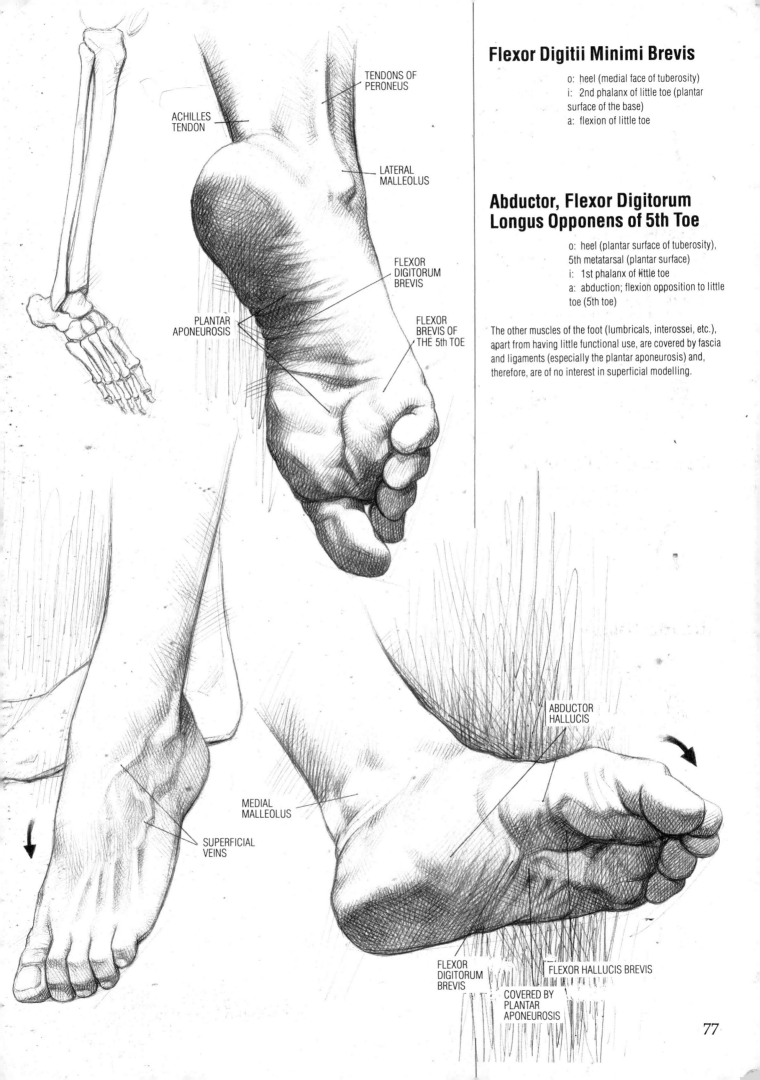

TENDONS OF
PERONEUS

ACHILLES
TENDON

LATERAL
MALLEOLUS

FLEXOR
DIGITORUM
BREVIS

PLANTAR
APONEUROSIS

FLEXOR
BREVIS OF
THE 5th TOE

MEDIAL
MALLEOLUS

SUPERFICIAL
VEINS

ABDUCTOR
HALLUCIS

FLEXOR
DIGITORUM
BREVIS

FLEXOR HALLUCIS BREVIS

COVERED BY
PLANTAR
APONEUROSIS

Flexor Digitii Minimi Brevis

o: heel (medial face of tuberosity)
i: 2nd phalanx of little toe (plantar
surface of the base)
a: flexion of little toe

Abductor, Flexor Digitorum Longus Opponens of 5th Toe

o: heel (plantar surface of tuberosity),
5th metatarsal (plantar surface)
i: 1st phalanx of little toe
a: abduction; flexion opposition to little
toe (5th toe)

The other muscles of the foot (lumbricals, interossei, etc.),
apart from having little functional use, are covered by fascia
and ligaments (especially the plantar aponeurosis) and,
therefore, are of no interest in superficial modelling.

77

BONE STRUCTURE

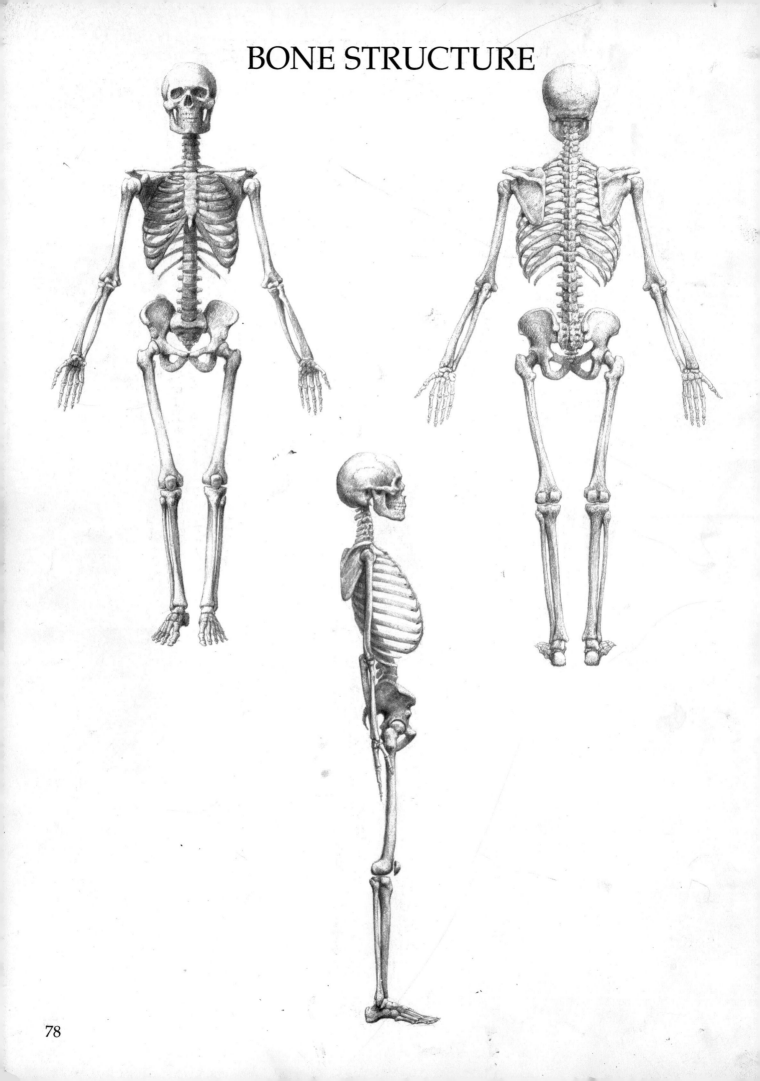

MUSCLE STRUCTURE

THE LOCOMOTOR APPARATUS

Trunk

TORSO

Osteology

Spine: 7 cervical vertebrae
12 thoracic vertebrae
5 lumbar vertebrae
5 sacral vertebrae
3 coccygeal vertebrae

Arthrology

Articulations between the vertebral bodies
Articulations between the articulatory processes
Longitudinal ligaments (ant. and post.)
 of the spine
Ligaments between the vertebral arches
 interlaminary ligaments
 intertransverse ligaments
 interspinous ligaments
Craniovertebral articulations

Myology

Muscles of the vertebral sulci
1 Superficial: (sacrospinal)
(a) iliocostalis
(b) longissimus

2 Intermediary
(a) spinalis
(b) transverse–spinal
(i) semispinalis
(ii) multifidus
(iii) rotatores
(c) splenius
(i) splenius cervicis
(ii) splenius capitis

3 Deep
(a) interspinous
(b) intertransverse
(c) suboccipital
(i) small pectus post.
(ii) large pectus post.
(iii) inferior oblique
(iv) superior oblique

Ventral musculature of the vertebral column
1 Prevertebral muscles
(a) longus cervicis
(b) longus capitis
(c) anterior and lateral rectus

 2 Sacrococcygeal musculature

Muscular fasciae

 nuchal fascia
 lumbar–dorsal fascia

NECK

Osteology

 hyoid bone
 cartilages of the larynx

Myology

Scalenus muscles
1 scalenus anterior
2 scalenus medius
3 scalenus posterior

Sternocleidomastoid muscles

Suprahyoid muscles
1 digastric
2 stylohyoid
3 mylohyoid
4 geniohyoid

Infrahyoid muscles
1 sternohyoid
2 mylohyoid
3 sternothyroid
4 thyrohyoid

Muscular fasciae

 medial cervical fascia
 deep cervical fascia

THORAX
Osteology

 12 ribs
 10 costal cartilages
 sternum

Myology

Intercostal musculature
1 external intercostal muscles
2 levatores costarum
3 internal intercostal muscles
4 subcostal
5 transversus thoracis

Spinocostal muscles
1 serratus posterior superior
2 serratus posterior inferior

Diaphragm

Arthrology

Costovertebral articulations
1 from head of rib to vertebral body
2 between the costal tubercle and the
 transverse process

Sternocostal articulations

ABDOMEN

Osteology

Pelvis (hip-bone)
 ischium
 ilium
 pubis

Arthrology

 sacroiliac articulation
 symphysis pubis
 ligaments of pelvis

Myology

Lumbar vertebral musculature
1 quadratus lumborum

Rectus anterior musculature
1 rectus abdominis
2 pyramidalis

Broad lateral abdominal muscles
1 external oblique
2 internal oblique
3 transversus abdominis

Muscle fasciae

Fascia of external oblique
 transverse fascia
 sheath of rectus muscle
 inguinal ligament, etc.

PERINEUM
Myology

Pelvic diaphragm
1 ischium
2 external anal sphincter
3 supporting fasciae

Muscles and fasciae of the perineum
1 sphincter urethrae
2 muscles of the genital region

Head

Osteology

Cranium

Cranial vault
1 occipital bone
2 sphenoid bone
3 frontal bone
4 temporal bone
5 parietal bone

Facial block
1 nasal region
(a) ethmoid
(b) nasal bone
(c) lacrimal bone
(d) vomer
2 maxillary region
(a) maxilla
(b) palatine bone
(c) zygomatic bone
(d) mandible

Arthrology

Sutural articulations
1 coronal suture
2 sagittal suture
Temporomandibular articulation

Myology

Masticatory muscles
1 temporal
2 masseter
3 lateral pterygoid
4 medial pterygoid

Accessory muscular fasciae
1 temporal fascia
2 parotidean fascia
3 Bichat's fat-pad

Mimesis musculature

1 platysma

2 muscles of the region of the mouth
(a) pertaining to the lower lip
(i) triangularis
(ii) quadratus labii inferioris
(iii) incisor of the lower lip
(b) pertaining to the upper lip
(i) zygomaticus
(ii) quadratus labii superioris
(iii) caninus
(iv) incisor
(v) buccinator
(vi) orbicularis oris
(vii) muscles of the chin

3 Muscles of the nose

4 Muscles of the region of the eyes
(a) orbicularis oculi
(b) corrugator muscle of the eyebrows
Epicranial muscle (frontal and occipital)
Muscles of the auricle

Upper Limb

Osteology

Shoulder girdle
 clavicle
 scapula

Arm
 humerus
Forearm
 radius
 ulna
Hand
 carpals (eight bones)
 metacarpals (five bones)
 phalanges

Arthrology

Articulations of the shoulder girdle
1 acromioclavicular
2 sternoclavicular

Articulations of the free part
1 scapulohumeral
2 elbow
3 radiocarpal
4 radioulnar distal

Articulations of the hand
1 mid-carpal
2 carpometacarpal
3 phalanges of metacarpals
4 interphalangeal joints, etc.

Myology

Axio-appendicular muscles
1 Thoracic–appendicular muscles
(a) 1st layer
(i) pectoralis major
(b) 2nd layer
(i) subclavian
(ii) pectoralis minor
(c) 3rd layer
(i) serratus anterior

2 Spinous appendicular muscles
(a) superficial level
(i) trapezius
(ii) latissimus dorsi
(b) deep level
(i) elevator of scapula
(ii) rhomboid

Muscles of the upper limb

1 Muscles of the shoulder
(a) deltoid
(b) subscapular
(c) supraspinatus
(d) subspinatus
(e) teres minor
(f) teres major

2 Muscles of the arm
(a) anterior upper arm muscles (flexors)
(i) biceps
(ii) coracobrachialis
(iii) brachialis
(b) posterior upper arm muscles (extensors)
(i) triceps
(ii) anconeus

3 Muscles of the forearm
(a) anterior forearm muscles (flexors)
(i) pronator teres
(ii) flexor carpi radialis
(iii) palmaris longus
(iv) flexor carpi ulnaris
(v) flexor digitorum profundus (of the epicondyle)
(i) brachioradialis
(ii) extensor carpi radialis longus (deep muscles)
(i) flexor digitorum profundus
(ii) flexor pollicis longus
(iii) pronator quadratus
(b) posterior forearm muscles (extensors)
 (superficial muscles)
(i) extensors of the fingers
(ii) extensor digiti minimi
(iii) extensor carpi ulnaris (deep muscles)
(i) supinator
(ii) abductor pollicis longus
(iii) extensor pollicis brevis
(iv) extensor pollicis longus
(v) extensor indicis

4 Muscles of the hand
(a) thenar group
(i) abductor pollicis brevis
(ii) flexor pollicis brevis
(iii) opponens pollicis brevis
(iv) adductor pollicis brevis
(b) hypothenar
(i) abductor digiti minimi
(ii) flexor digiti minimi brevis
(iii) opponens digiti minimi
(c) central muscles of the hand
(i) lumbricals (four)
(ii) palmar interossei (four)
(iii) dorsal interossei (four)

Muscular fasciae

single fascia divided topographically: shoulder,
 arm, etc.
ligaments and sheaths of tendons

Lower Limb

Osteology

1 Pelvic girdle: pelvis

2 Bones of the thigh
(a) femur
(b) patella

3 Bones of the leg
(a) tibia
(b) fibula

4 Bones of the foot
(a) tarsal bones
(i) talus
(ii) calcaneum
(iii) navicular
(iv) cuneiform
(v) cuboid
(b) metatarsals (five bones)
(c) phalanges

Arthrology

1 Articulations of the pelvic girdle (pelvis)
2 Articulations of the free part
(a) coxa (hip joint)
(b) knee
(c) tarsotibial
(d) tibiofibular

3 Articulations of the foot (with various ligaments)
(a) talocalcanean
(b) metatarsophalangeal

Myology

1 Spinoappendicular muscles
(a) psoas minor
(b) psoas major

2 Muscles of the gluteal region
(a) gluteus maximus
(b) tensor fasciae latae
(c) gluteus medius
(d) gluteus minimus
(e) piriformis
(f) obturator internus
(g) gemellus superior/inferior
(h) quadratus femoris

3 Muscles of the thigh
(a) anterior muscles
(i) sartorius
(ii) quadriceps
 rectus femoris
 vastus medialis
 vastus lateralis
 vastus intermedius
(iii) articulation of the knee
(b) medial femoral group
(i) pectineus
(ii) adductor longus
(iii) adductor brevis
(iv) gracilis
(v) adductor magnus and minimus
(vi) obturator externus
(c) posterior femoral group
(i) biceps femoris
(ii) semitendinosus
(iii) semimembranosus

4 Muscles of the leg
(a) anterior muscles
(i) tibialis anterior
(ii) extensor digitorum longus
(iii) peroneus tertius
(iv) extensor hallucis longus
(b) lateral muscles
(i) peroneus longus
(ii) peroneus brevis
(c) posterior muscles
(i) triceps surae
 gastrocnemius
 soleus
(ii) plantar muscle
(iii) popliteus
(iv) flexor digitorum longus
(v) tibialis posterior
(vi) flexor hallucis longus

5 Muscles of the foot
(a) dorsal muscles
(i) extensor digitorum brevis
(b) plantar muscles

(i) medial
abductor hallucis
flexor hallucis brevis
adductor brevis

(ii) lateral
abductor V digitorum
flexor brevis V digitorum
opponens V digitorum

(iii) central
flexor digitorum brevis
quadratus digitorum
lumbricals and interossei

Muscular fasciae
single fascia topographically divided
ligaments and sheaths of tendons

BIBLIOGRAPHY

Bairati, Angelo, *Trattato di anatomia umana*, Vol. IV: Apparato locomotore, Minerva Medica: Turin, 2nd ed., 1971

Barcsay, Jeno, *Anatomia per l'artista*, Corvina: Budapest, 1956 (Vallardi, A. ed., 1965)

Bianchi, Lorenzo, *Manuale di morfologia. Avviamenta allo studio della anatomia umana*, Casa Editrice Ambrosiana: Milan, 1978

Bridgman, George, B., *Constructive anatomy*, Dover: New York, 1973

Cunningham, D.J., *Cunningham's manual of practical anatomy*, 3 vol., Oxford University Press: London, 13th ed., 1966

Everard, John, *Model in movement*, The Bodley Head: London, 1959

Farris, Edmond J., *Art student's anatomy*, Dover: New York, 1961

Hale, R.B. and Coyle, T., *Albinus on anatomy*, Dover: New York, 1988

Hogarth, Burne, *Dynamic anatomy*, Watson Guptill: New York, 1985

Leonardo da Vinci, *Leonardo on the human body (Disegni anatomici)*, Dover: New York

Lockhart, R.D. et al., *Living anatomy*, Faber and Faber: London, 1963

Lombardini, Achille, *Anatomia pittorica*, Hoepli: Milan, 6th ed., 1923

Maimone, Giuseppe, *Anatomia artistica*, Edizioni Scientifiche Italiane: Naples, 3rd ed., 1970

Morelli, A. and G., *Anatomia per gli artisti*, Fratelli Lega Editori: Faenza, 9th ed., 1977

Moss, Albert A. et al., *Computed tomography of the body*, W.B. Saunders: Philadelphia, 1983

Muybridge, Eadweard, *The human figure in motion*, Dover: New York, 1955

Raynes, John, *Human anatomy for the artist*, Crescent: New York, 1979

Richer, Paul M., *Anatomie artistique*, Plon: Paris, 1890

Richer, Paul M., *Nouvelle anatomie artistique*, Plon: Paris, 1906–1920

Rimmer, William, *Art anatomy*, Dover: New York, 1962

Rohen, J. W. and Yokochi, C., *Anatomia umana. Atlante fotografico di anatomia sistematica e topografica*, EMSI: Rome, 1985

Schider, Fritz, *An atlas of anatomy for artists*, Dover: New York, 1957

Sheppard, Joseph, *Anatomy*, Watson Guptill: New York, 1975

Sobotta, Johannes, *Atlante di anatomia descrittiva dell'uomo*, Vol. 1, USES: Florence, 12th ed., 1972

Thomson, Arthur, *A handbook of anatomy for art students*, Oxford University Press: London, 1896